SUMMER NIGHTS

Hanna Karlzon

GIBBS SMITH

TO ENRICH AND INSPIRE HUMANKIND

28 27 26 25 24 13 12 11 10 9

Summer Nights
Illustrations © 2016 Hanna Karlzon.

Swedish edition copyright © 2016 Pagina Förlags AB, Sweden.
All rights reserved.

English edition copyright © 2016 Gibbs Smith Publisher, USA.
All rights reserved. No part of this book may be reproduced by any
means whatsoever without written permission from the publisher,
except brief portions quoted for purpose of review.

Gibbs Smith
P.O. Box 667
Layton, Utah 84041

1.800.835.4993 orders
www.gibbs-smith.com

Printed and bound in China

ISBN: 978-1-4236-4558-0

This book belongs to:

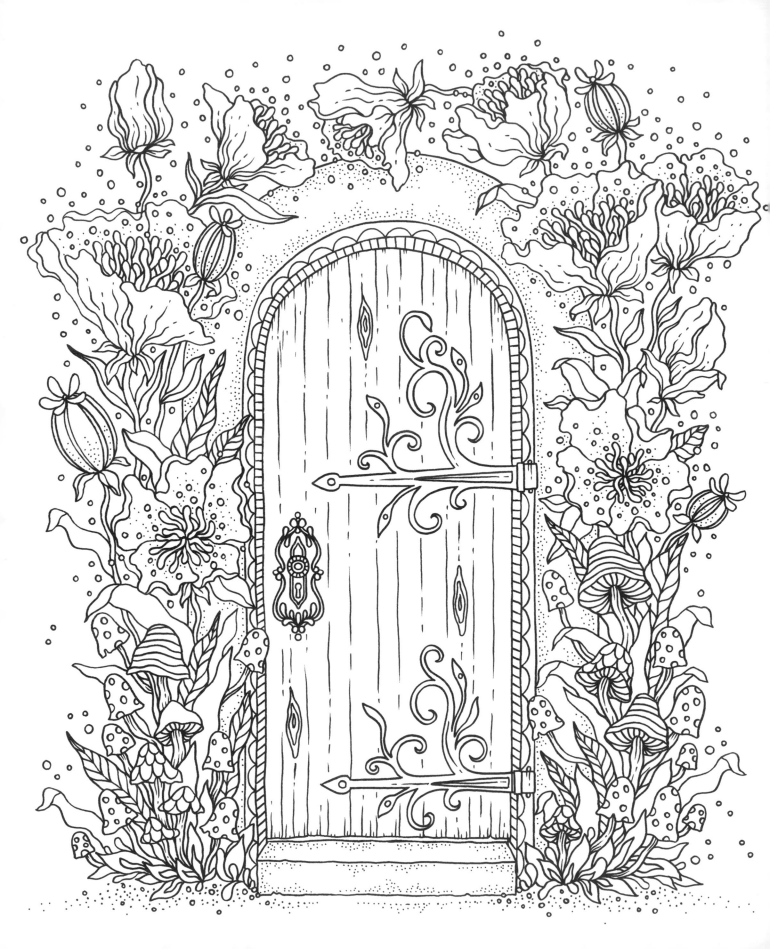

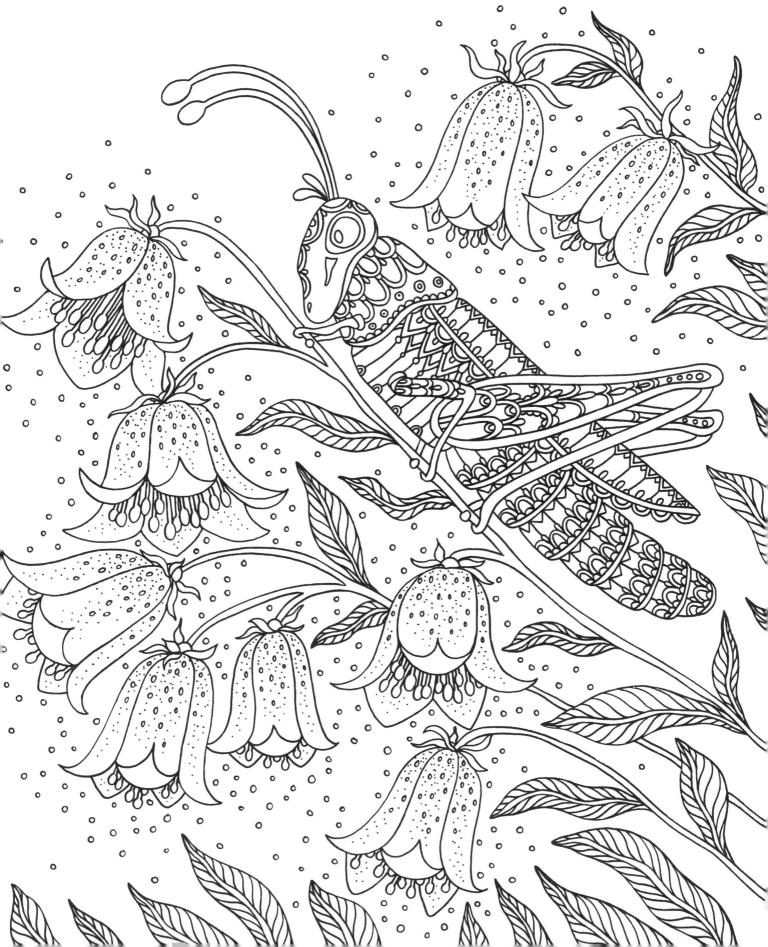

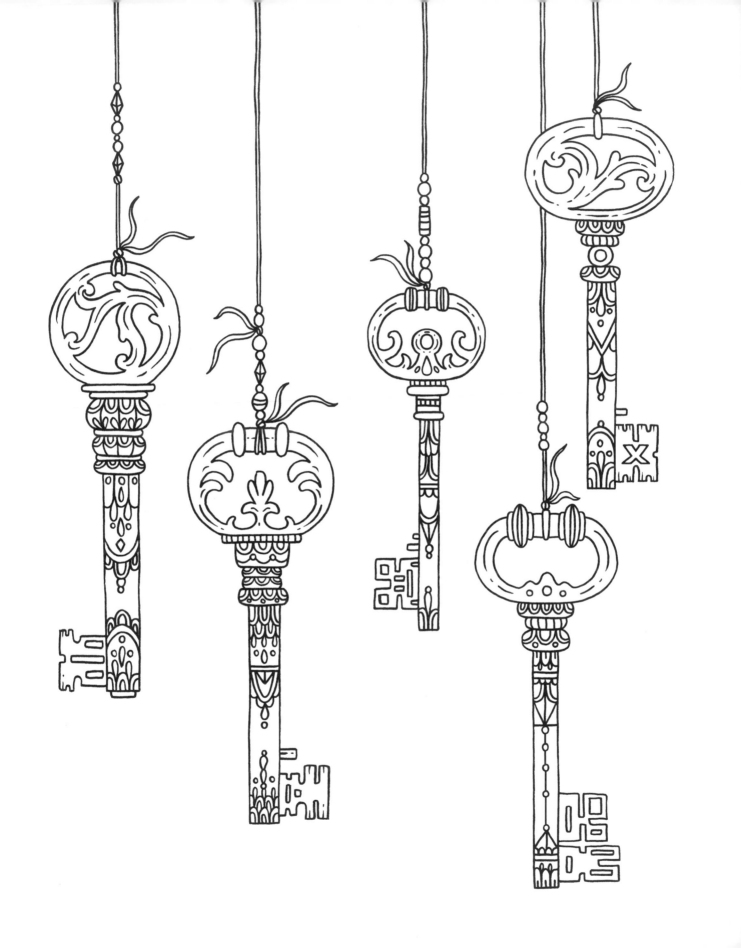

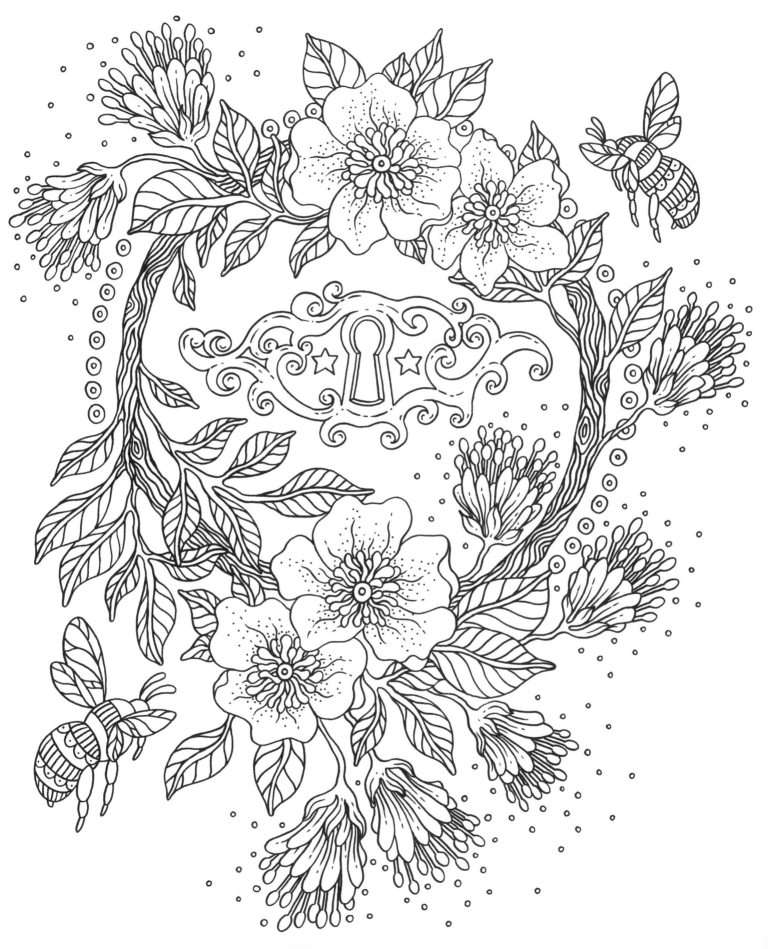

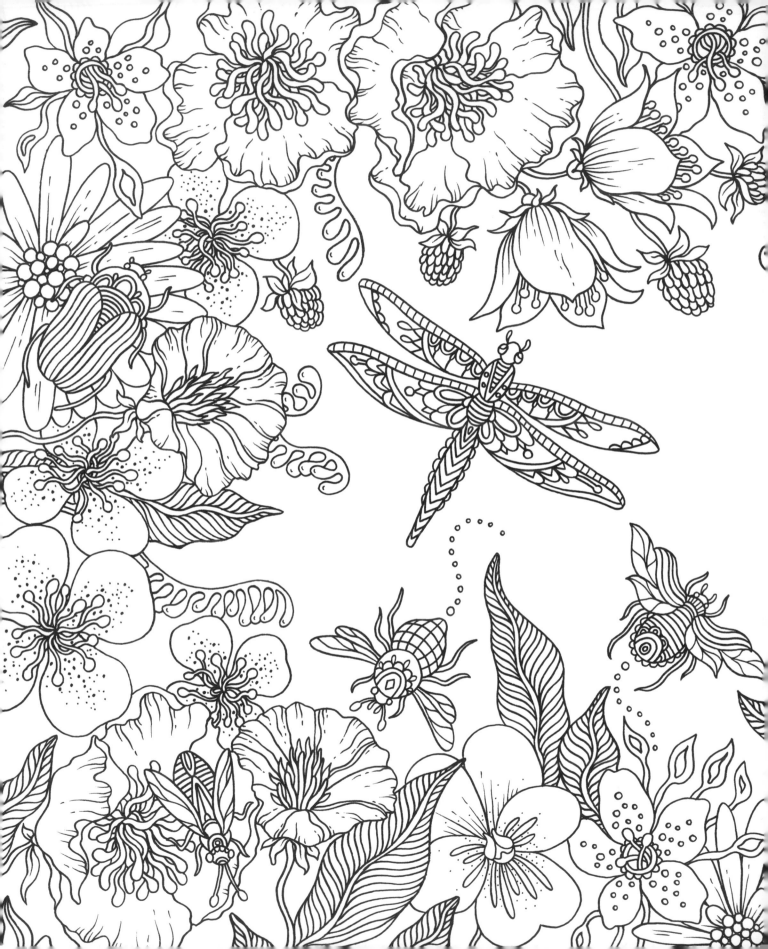

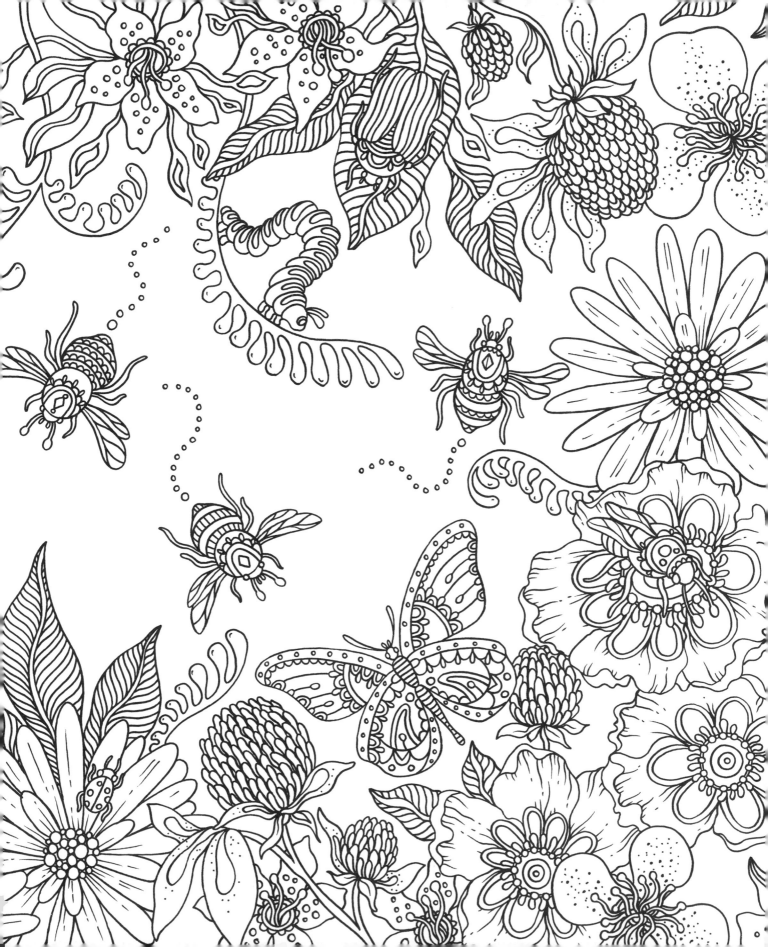

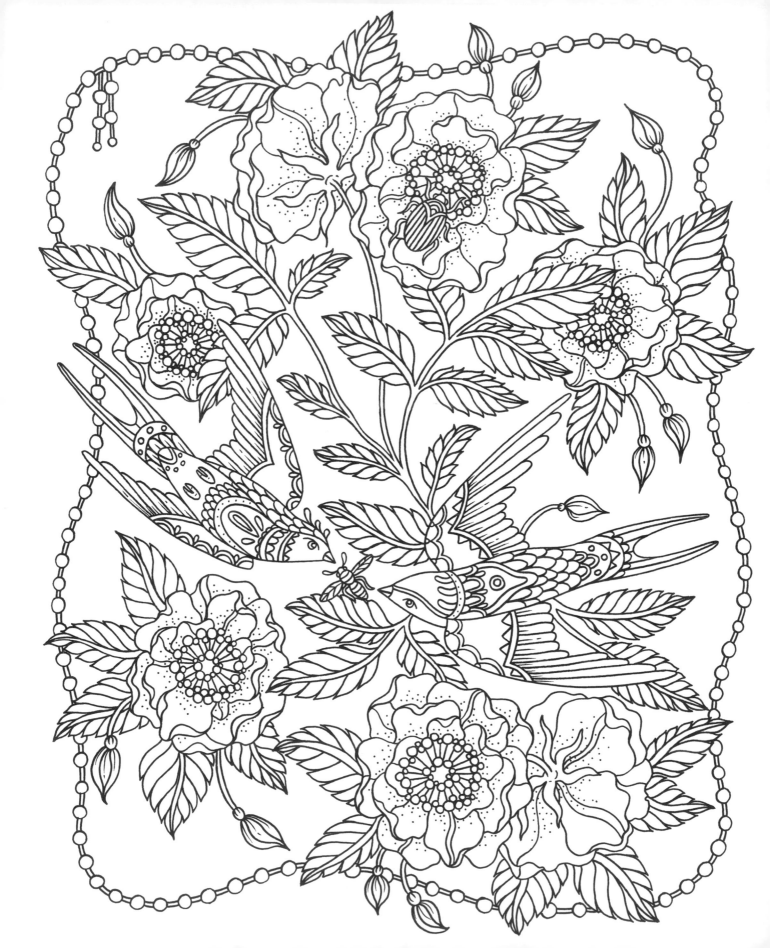

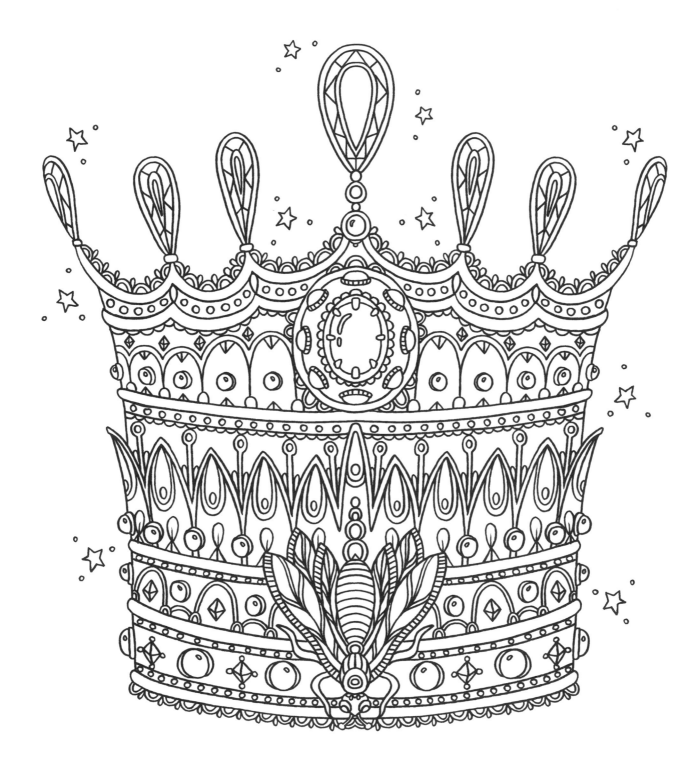

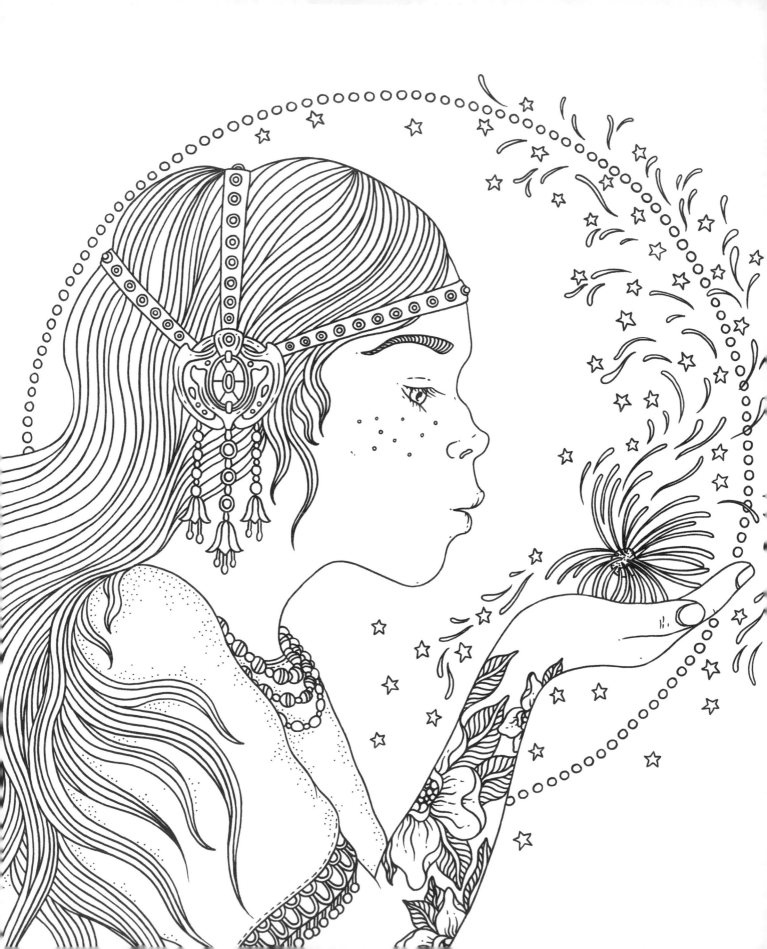

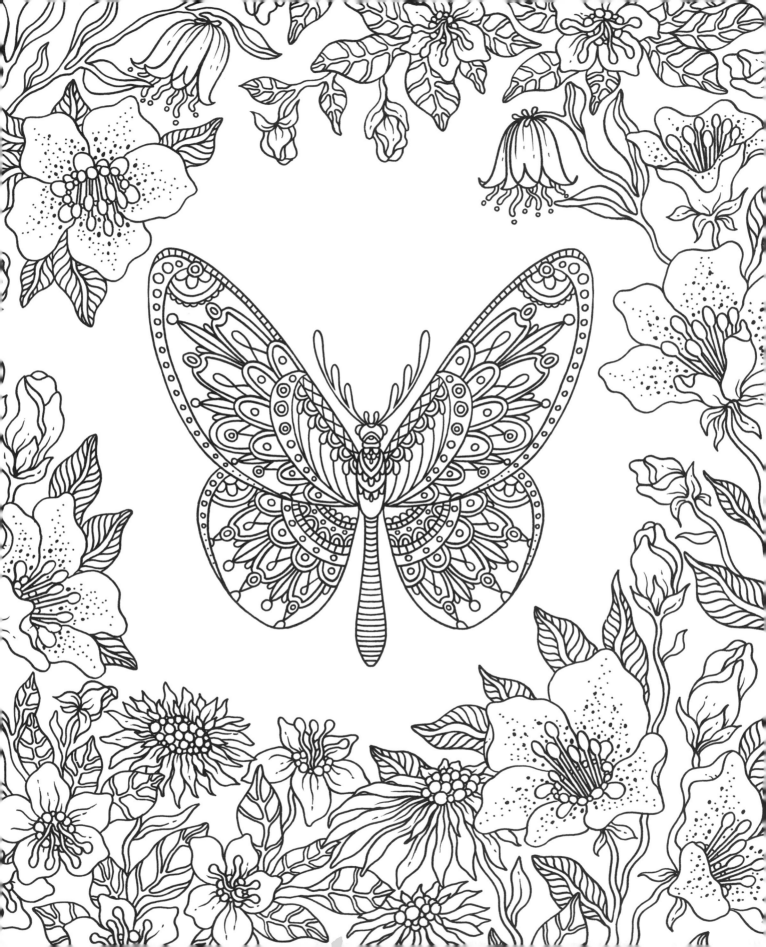

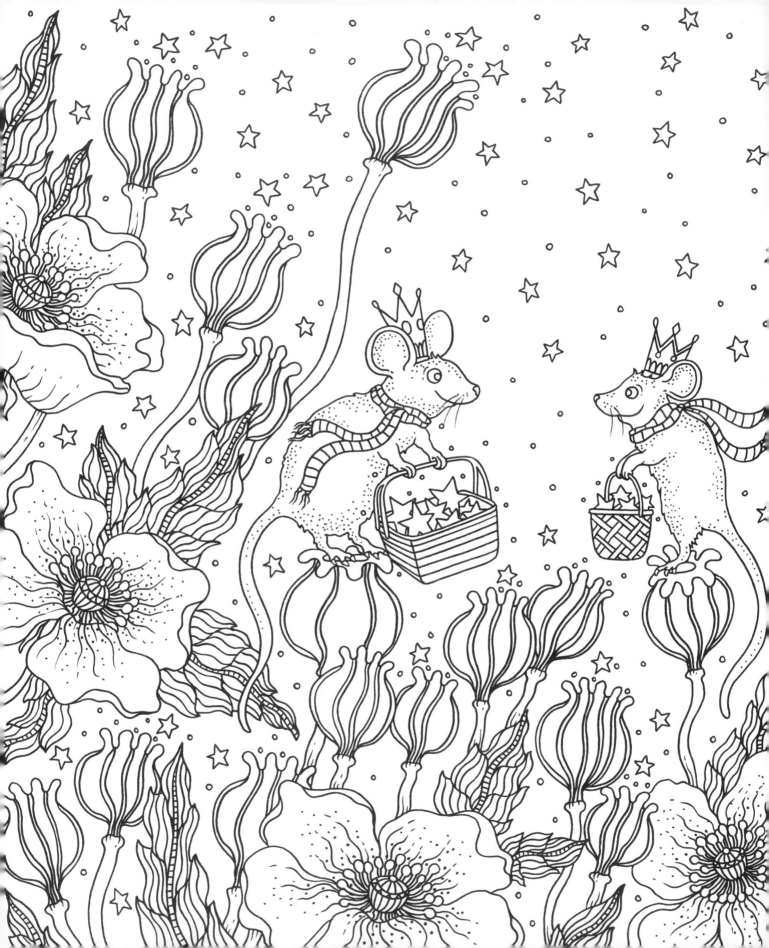

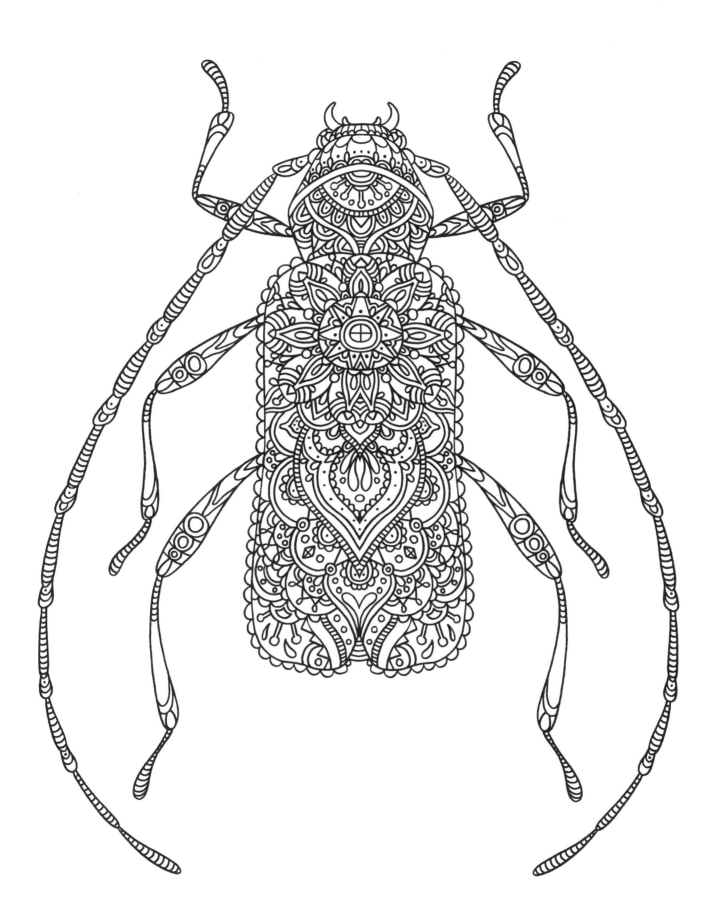

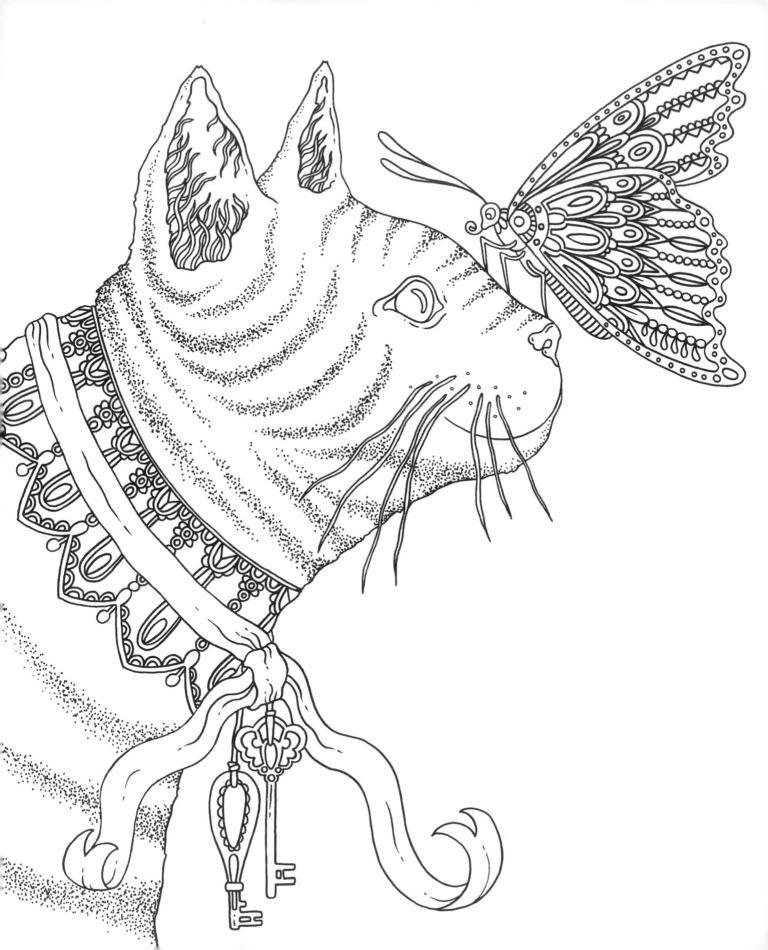

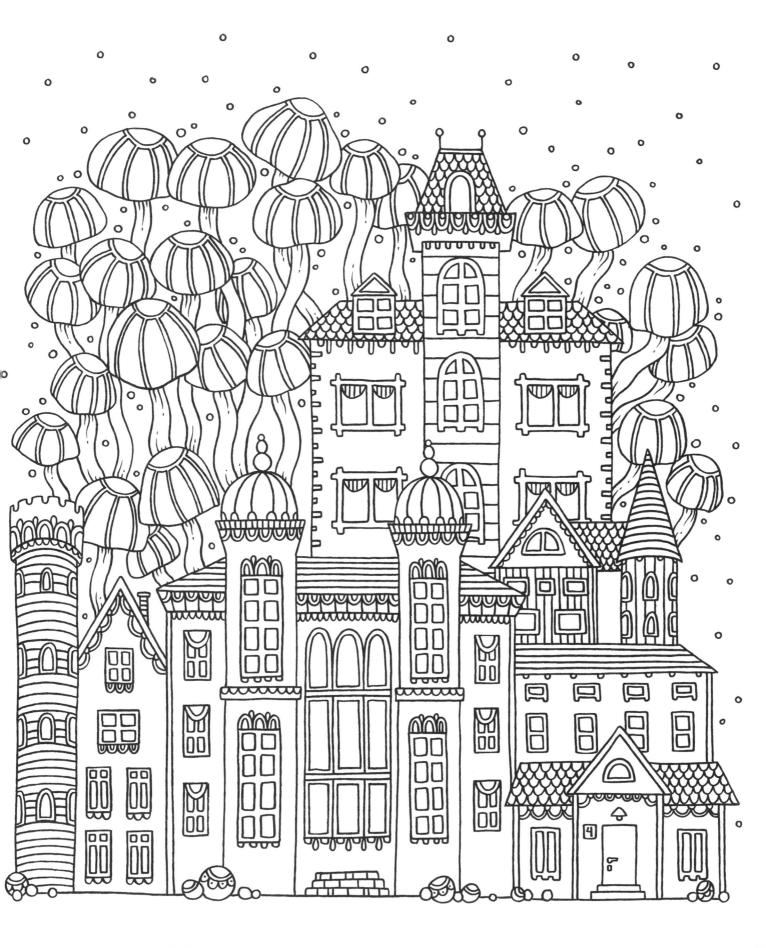

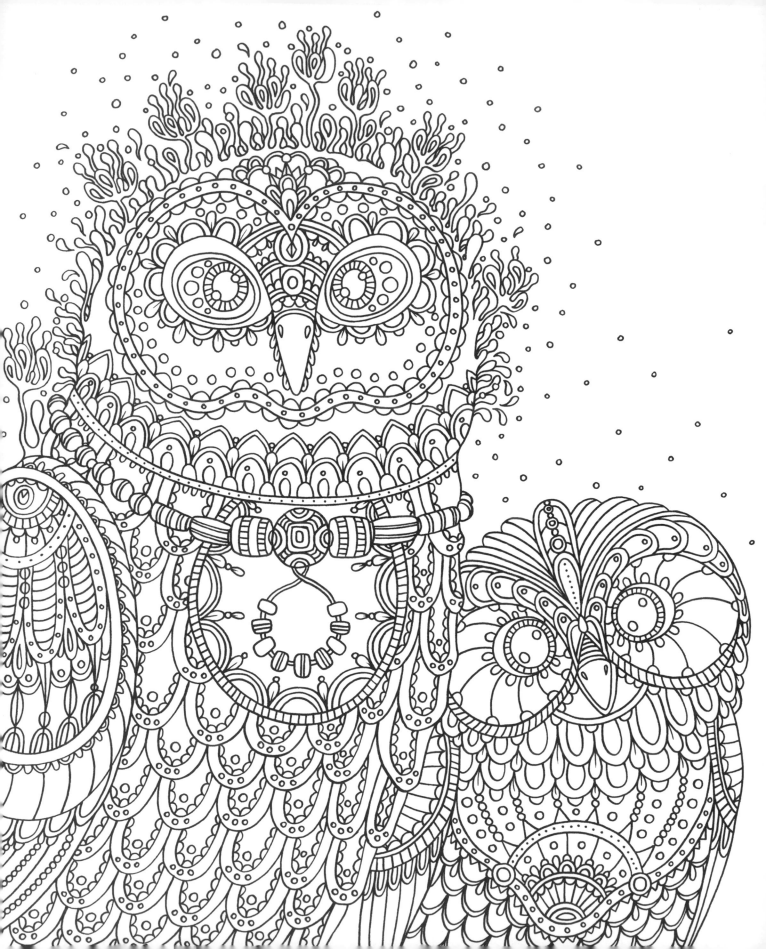

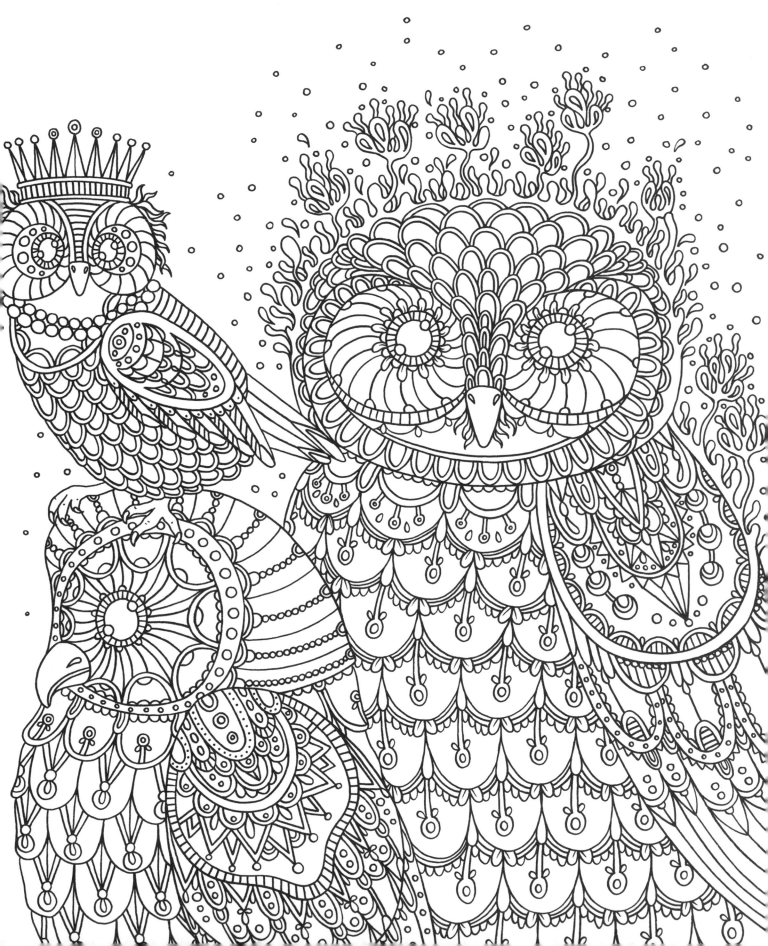

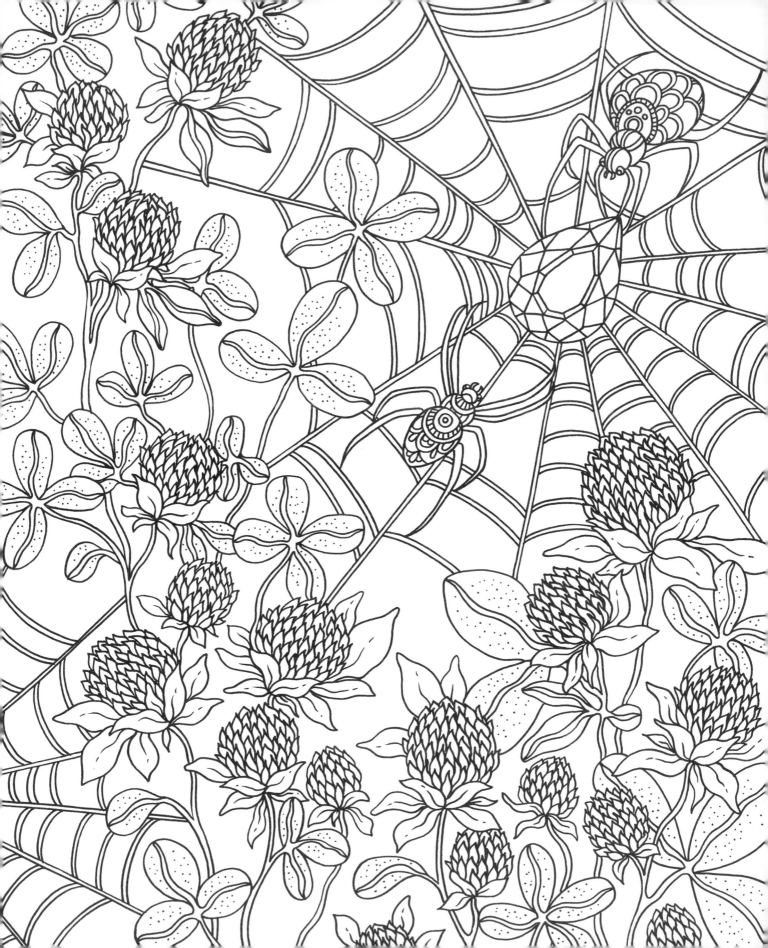

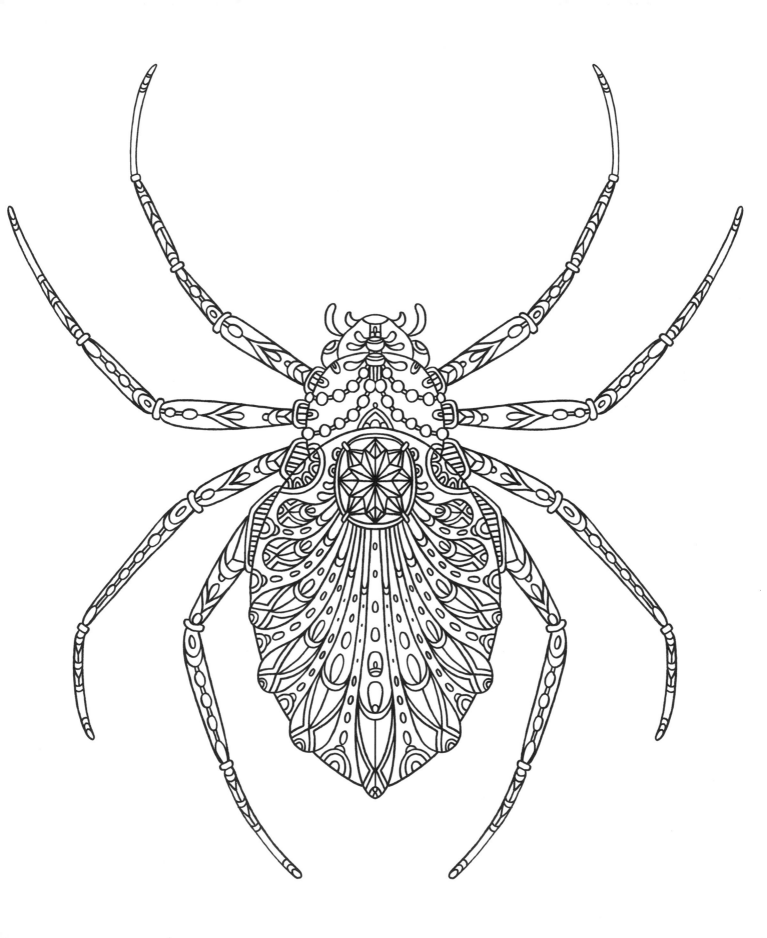

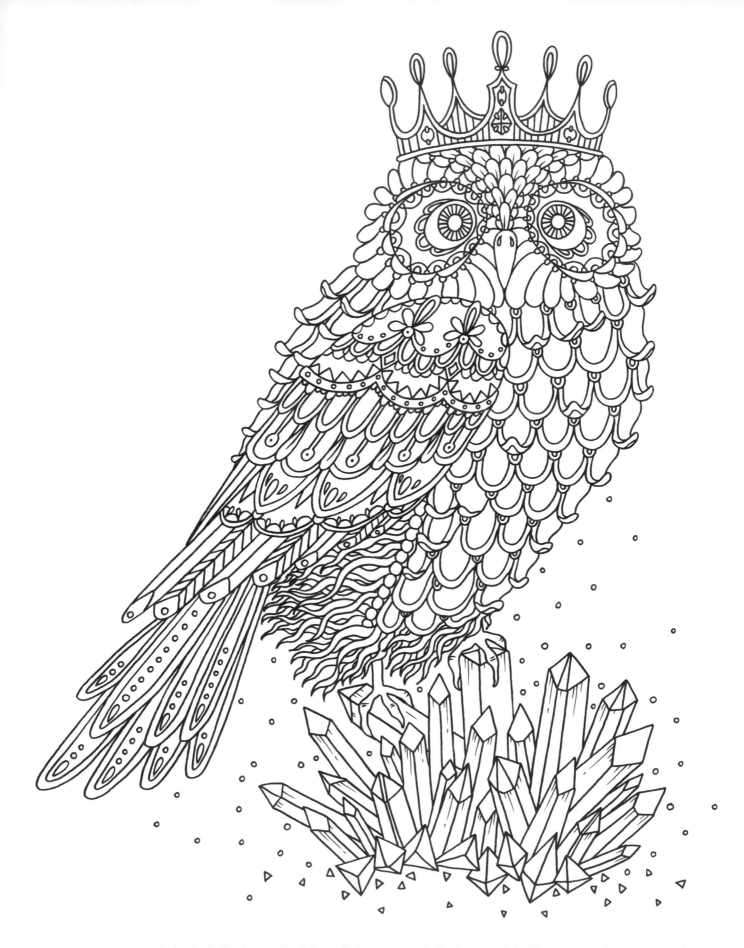

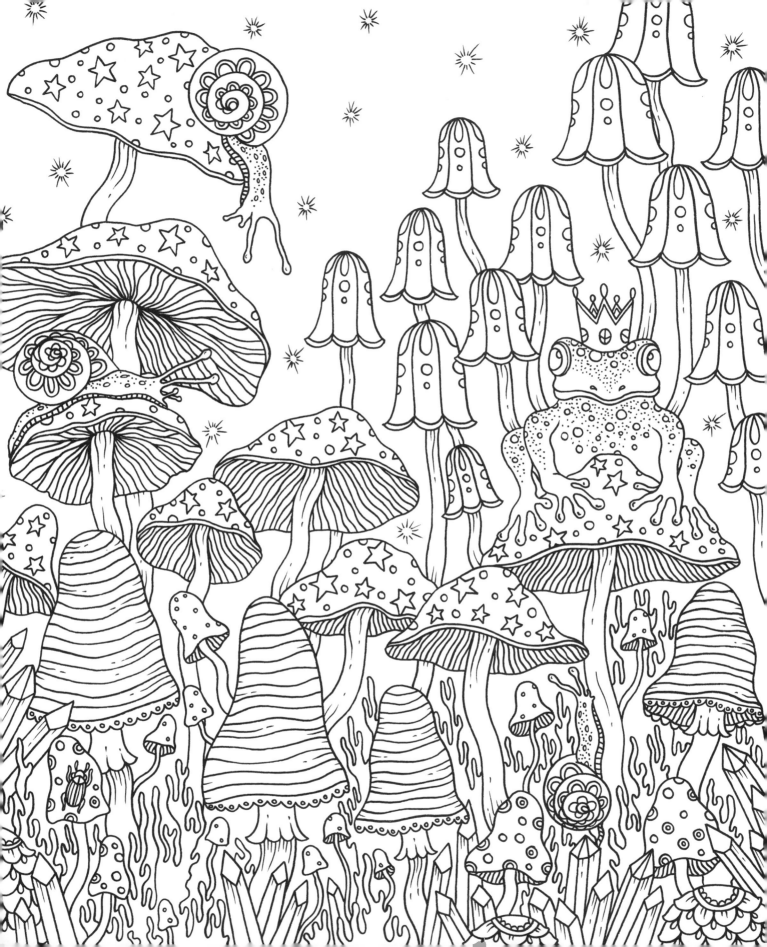

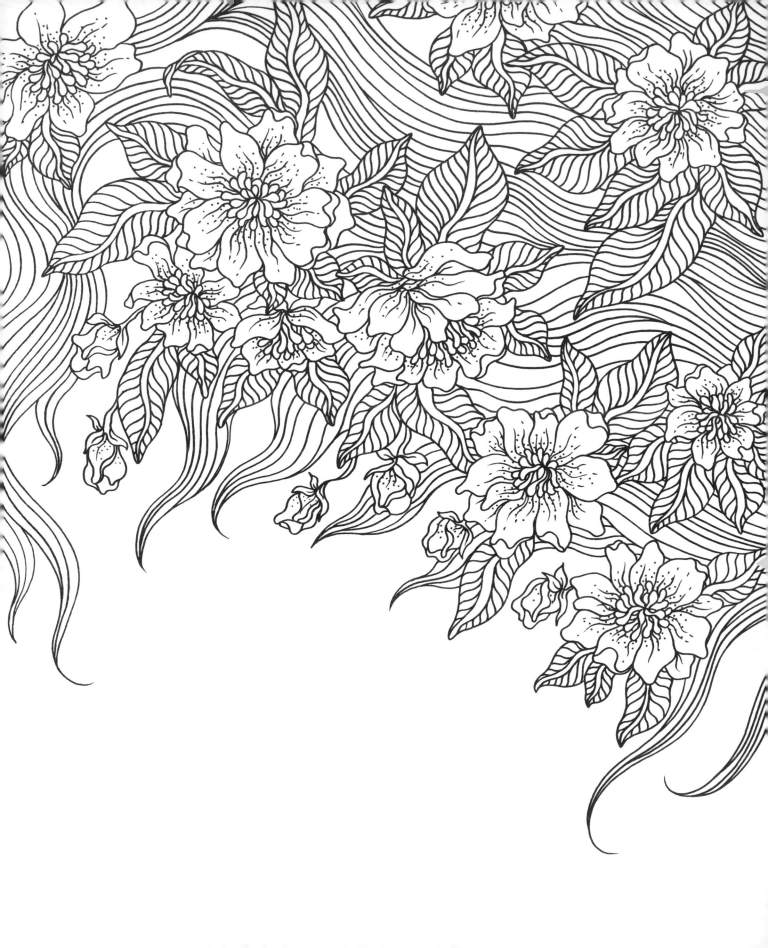

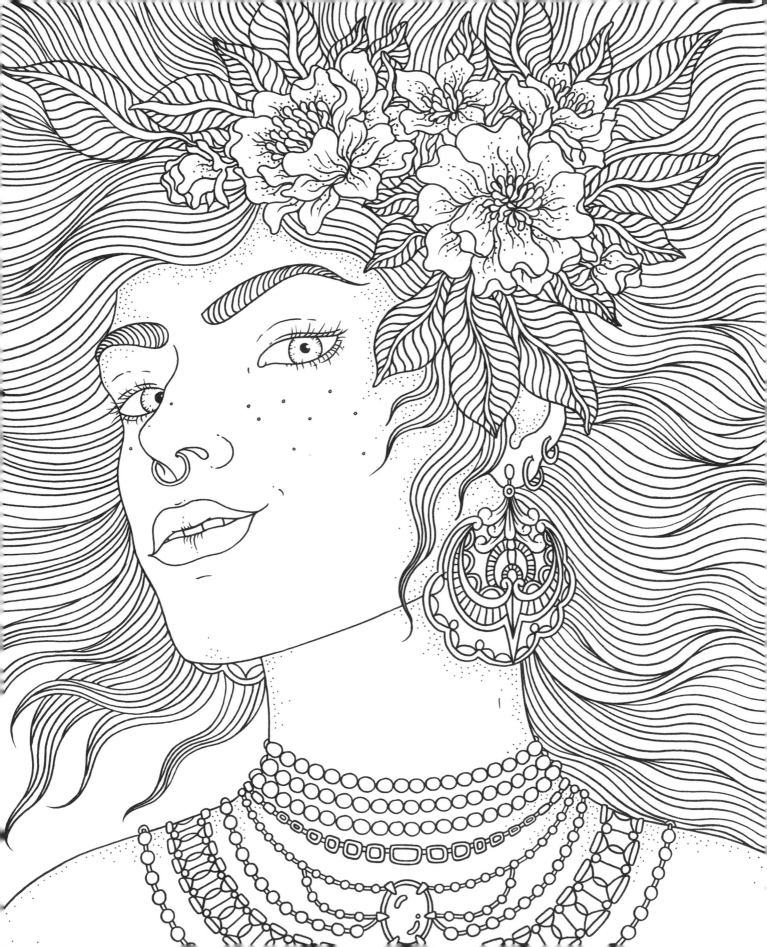

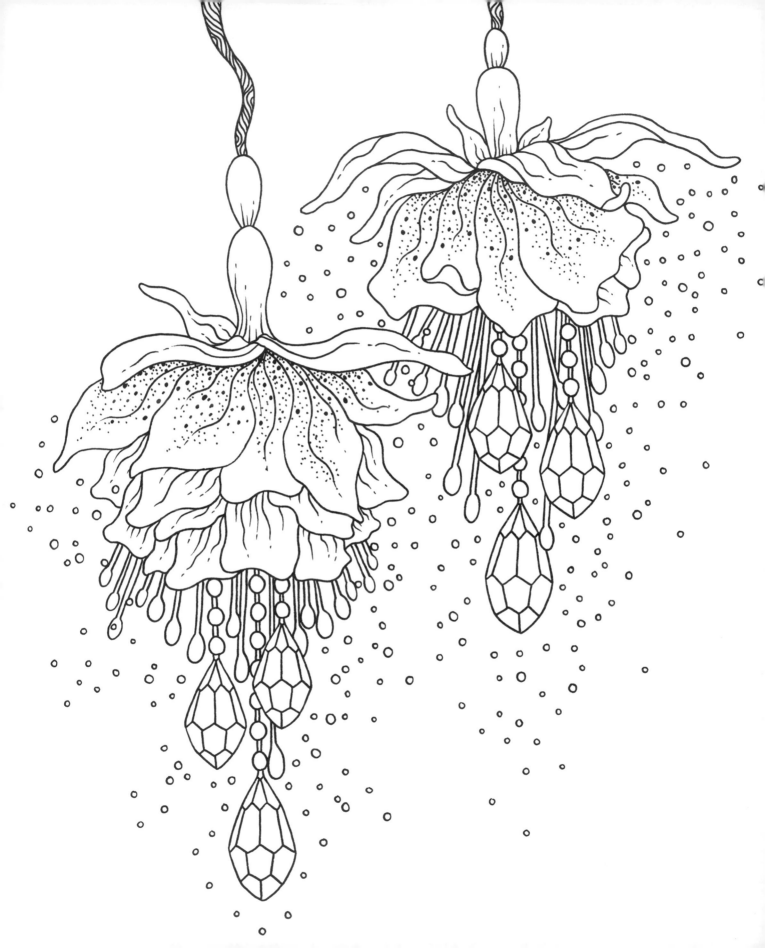

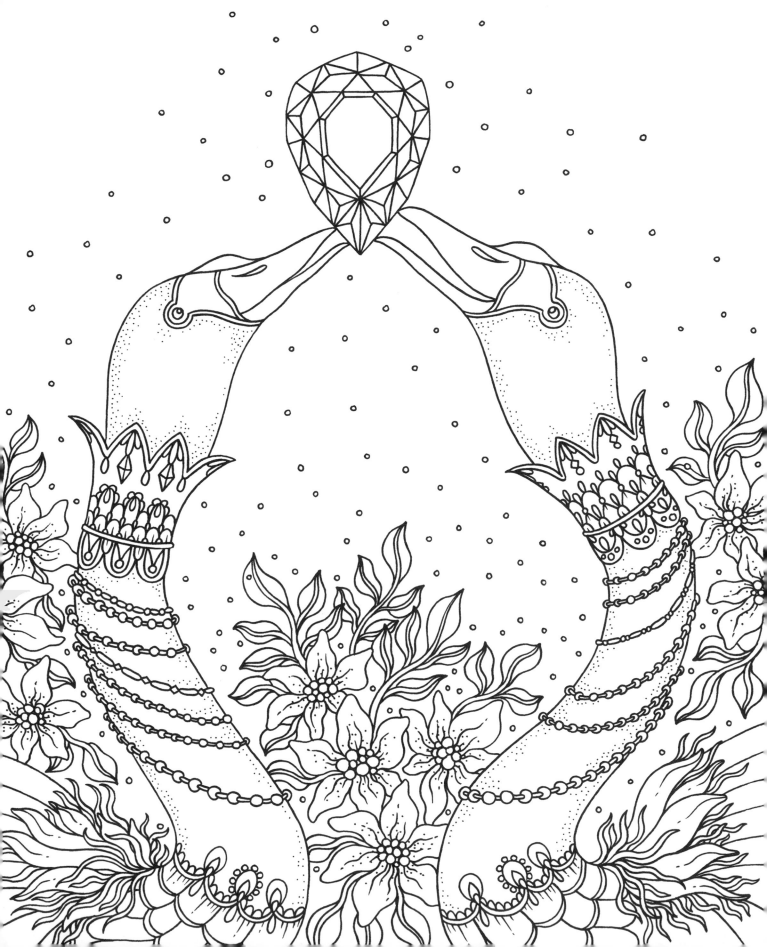

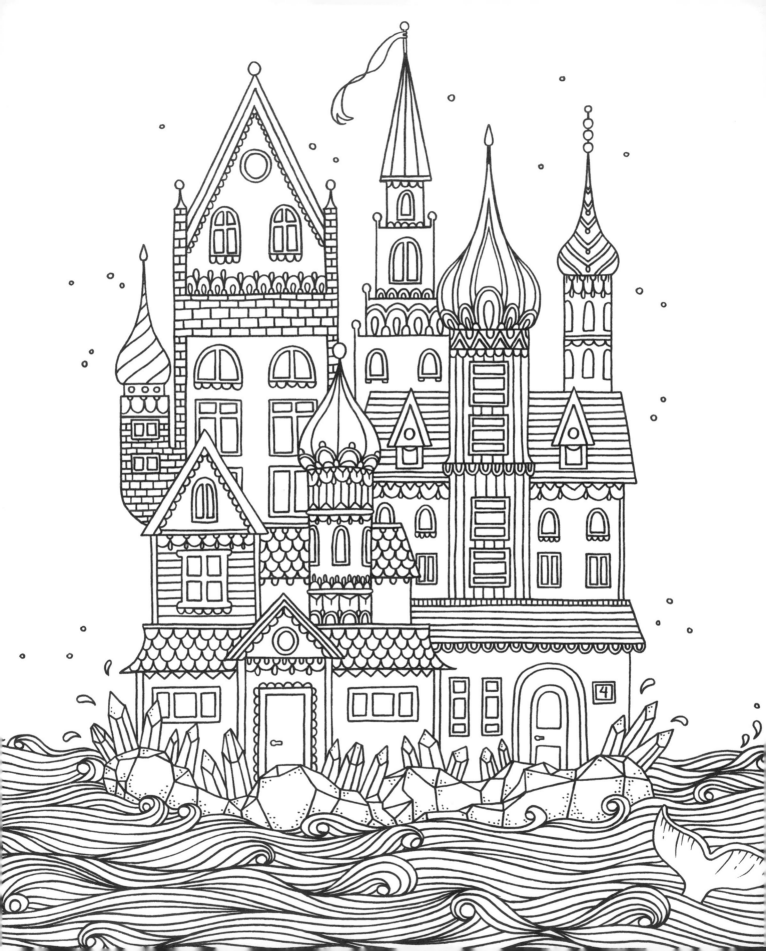

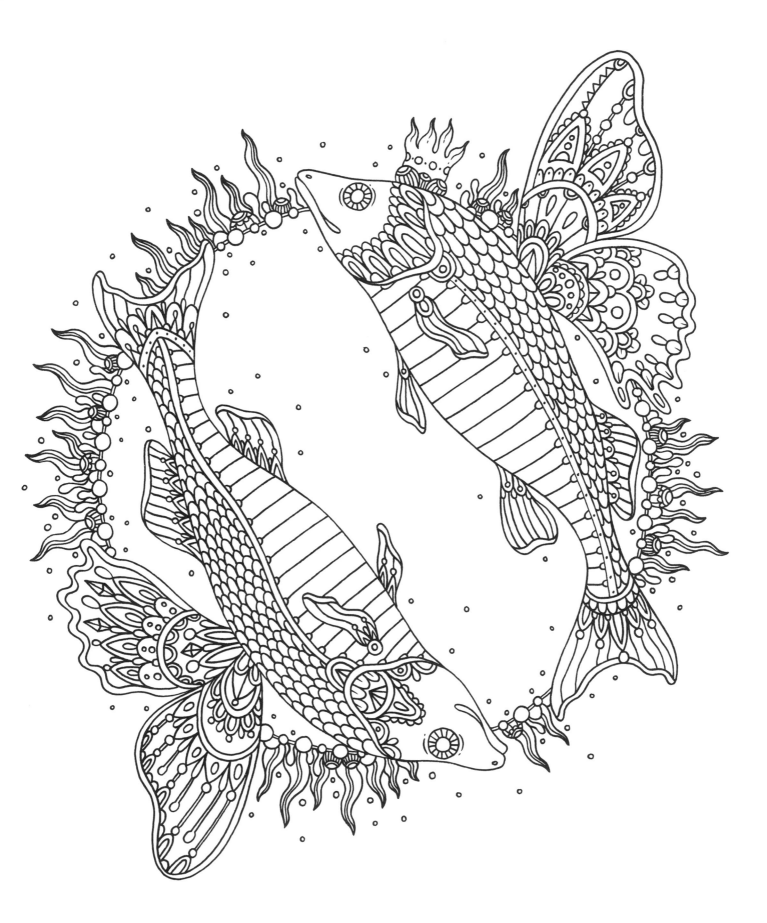

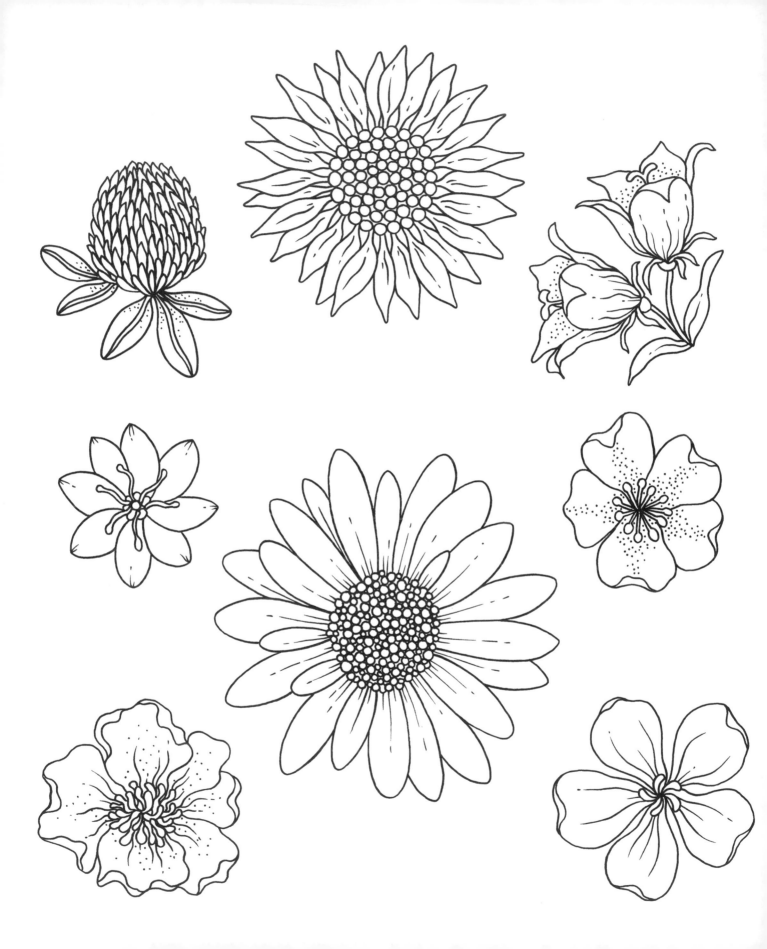

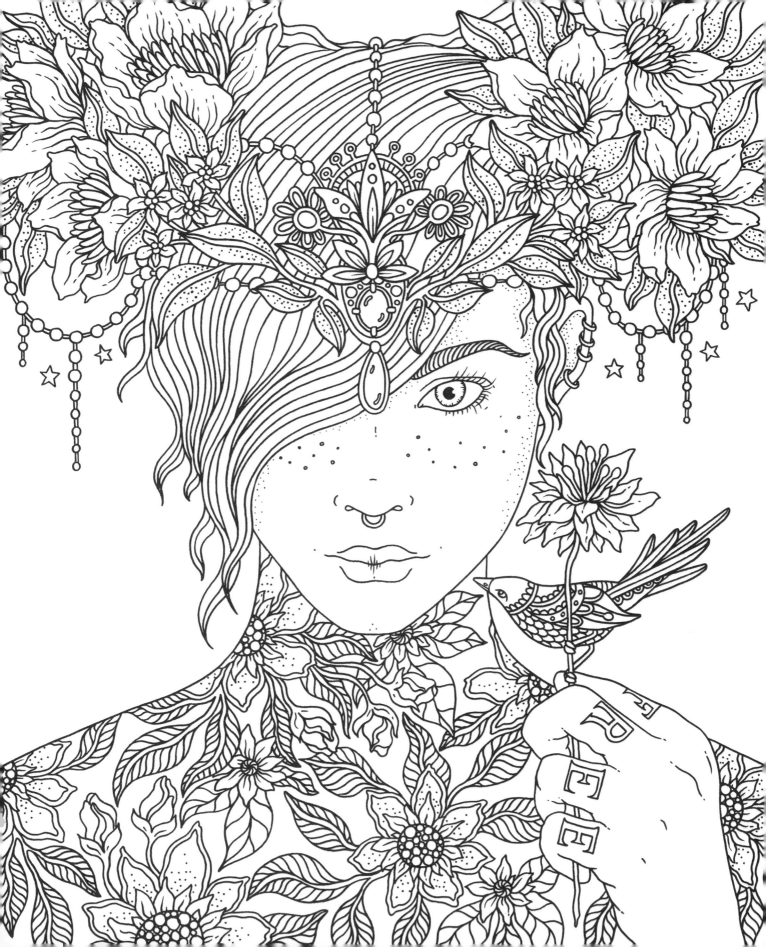

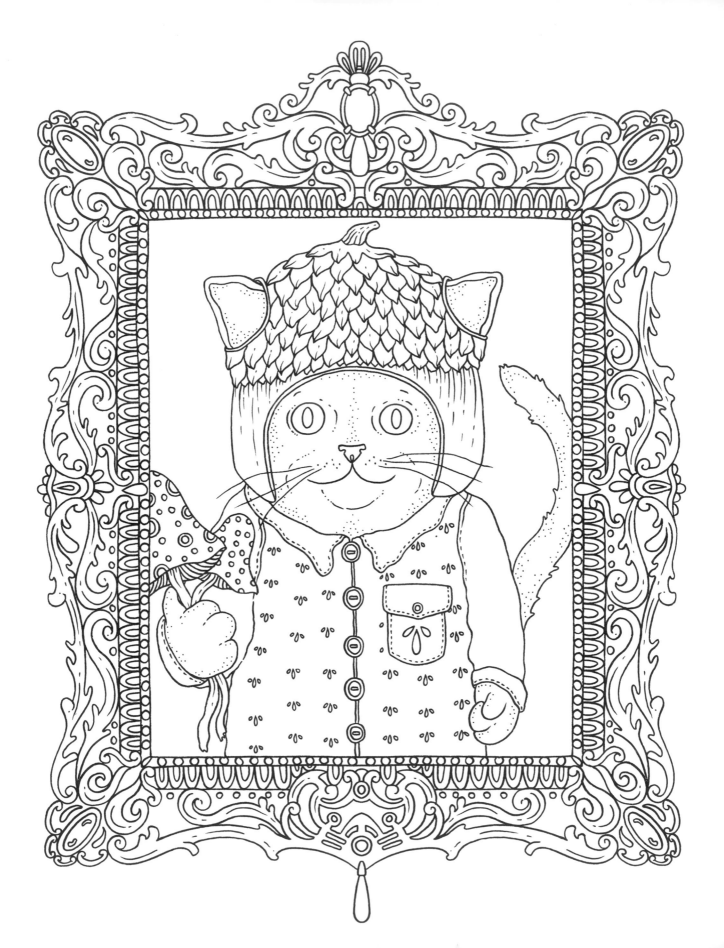

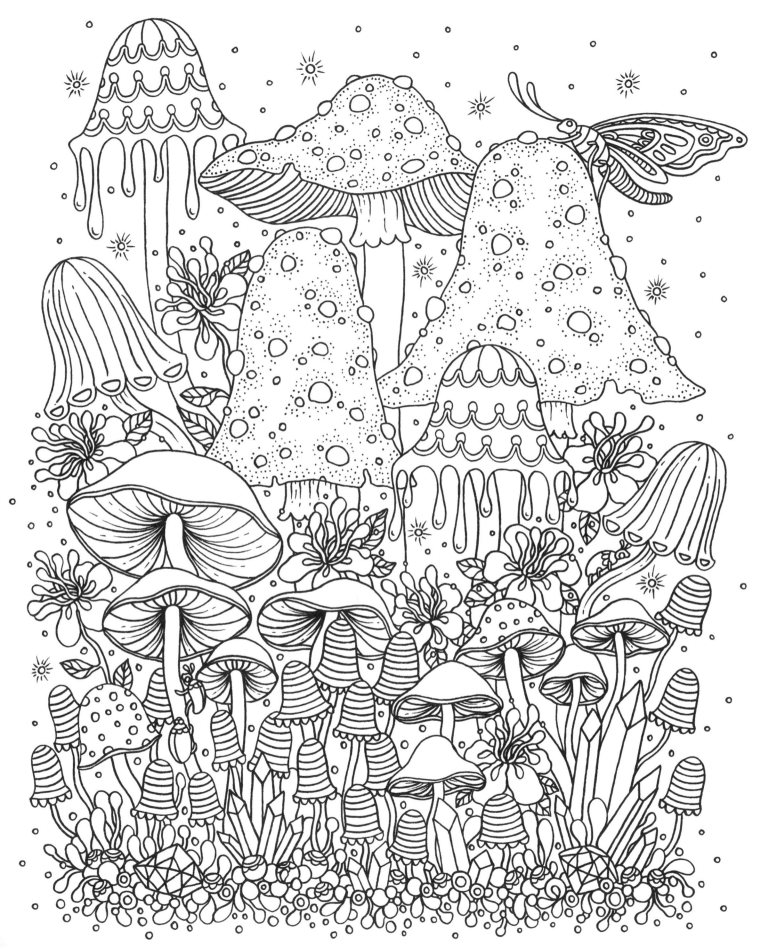

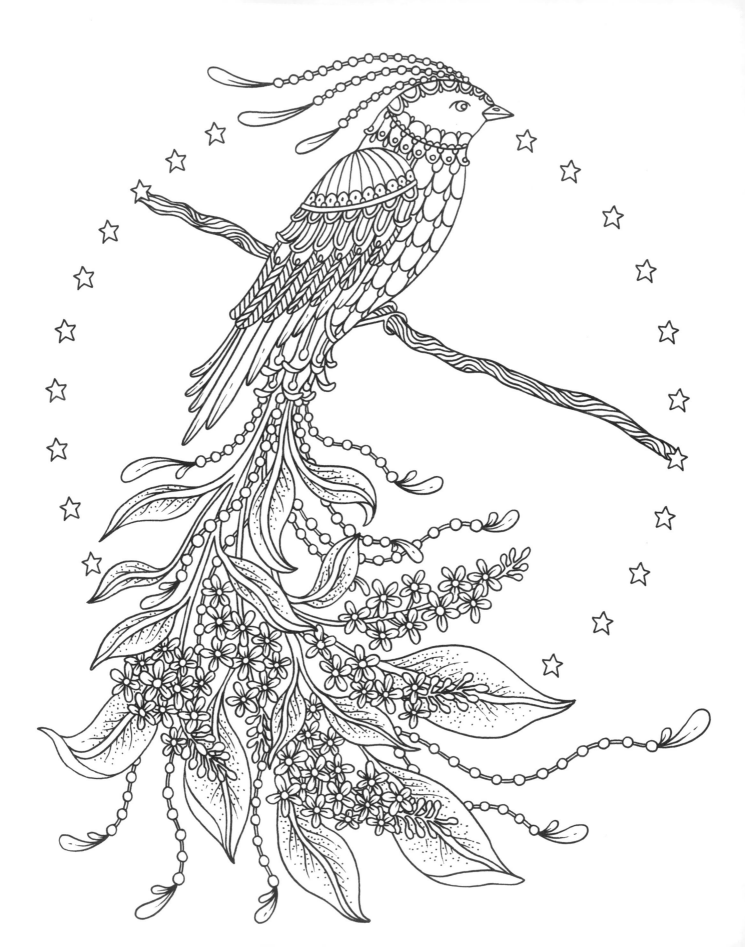

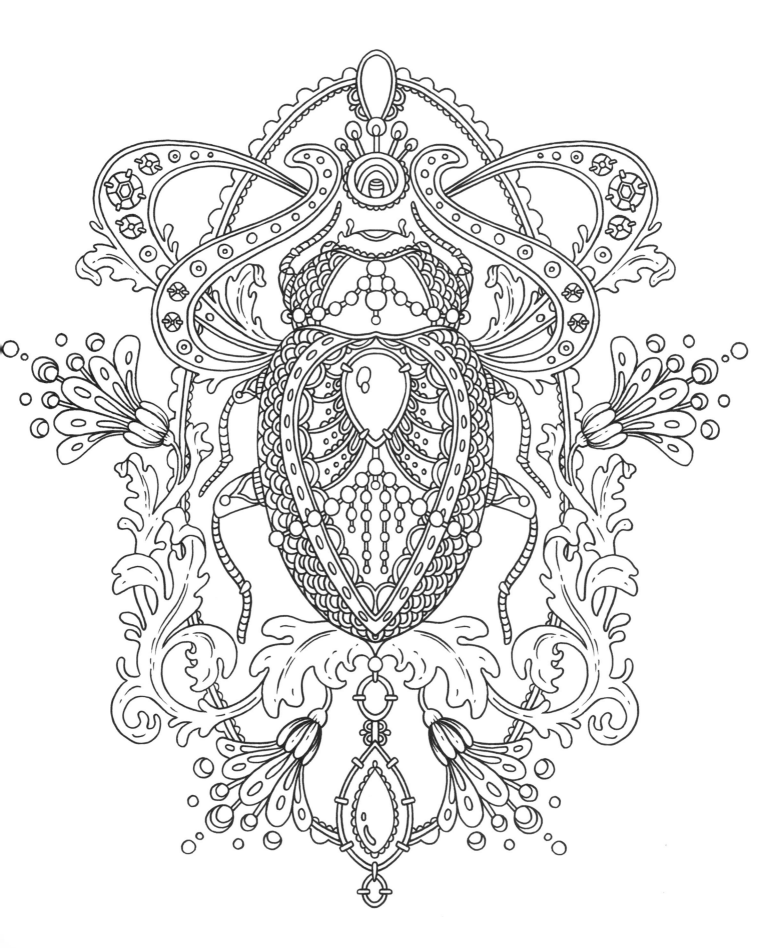

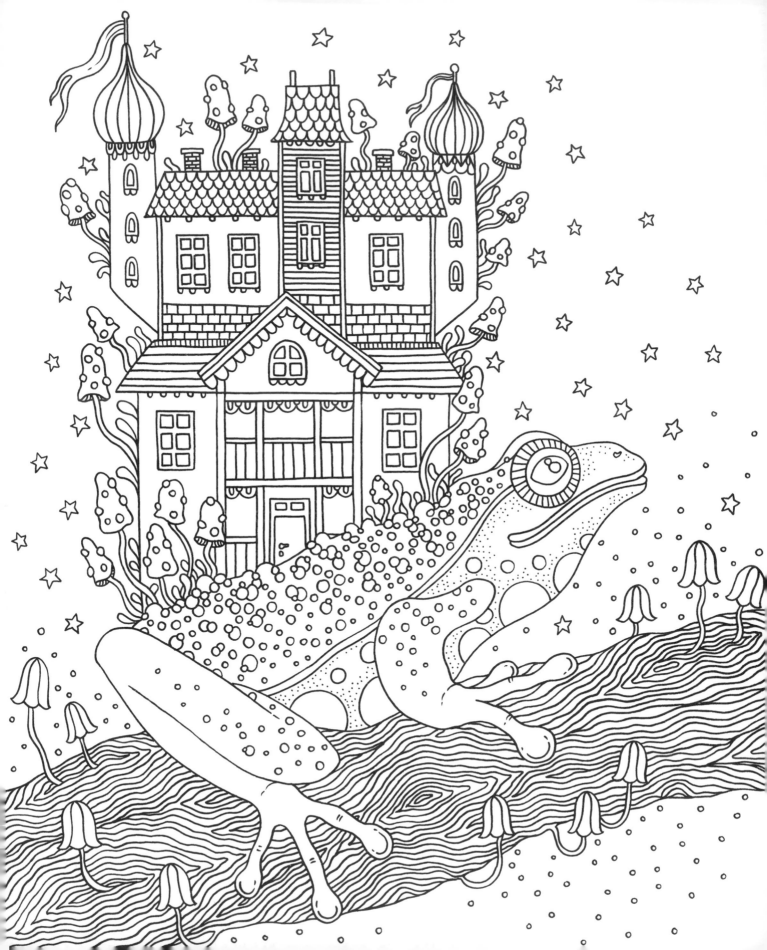

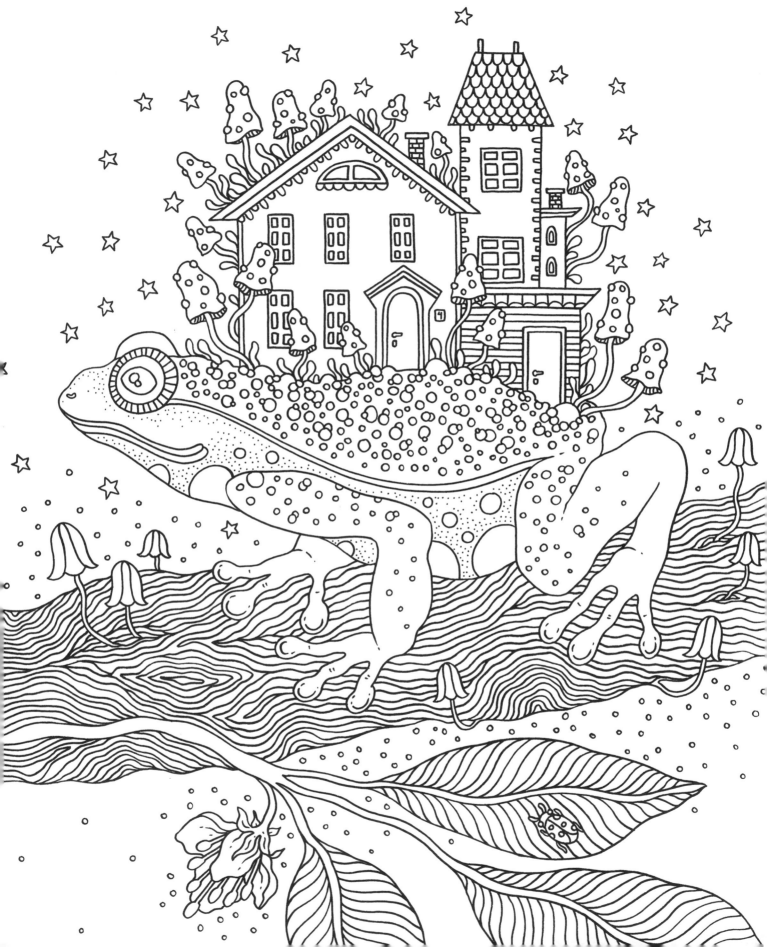

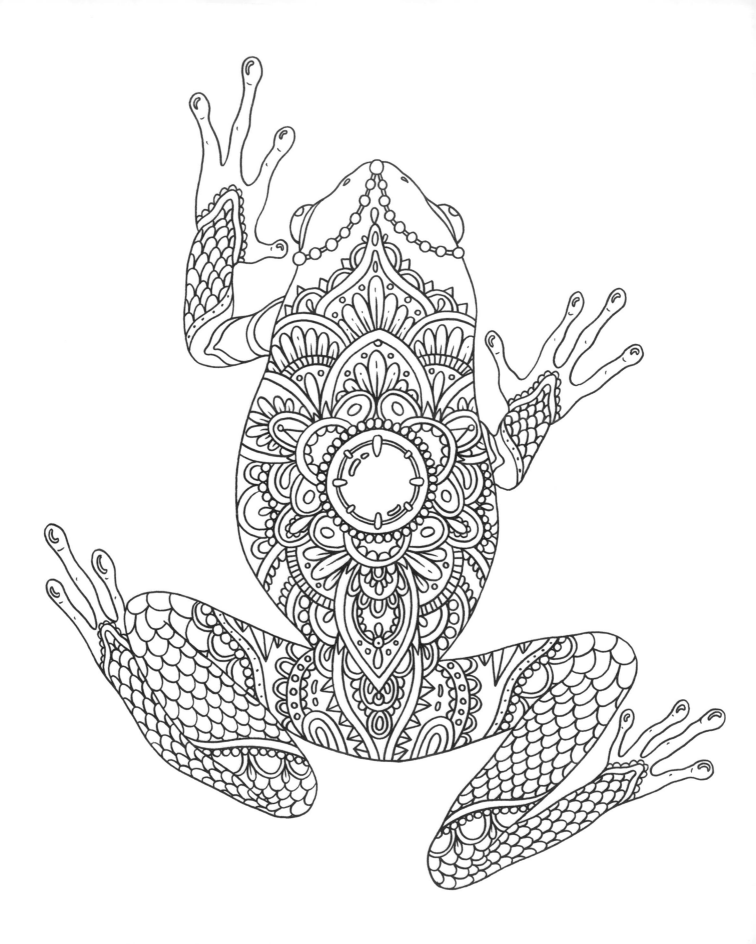

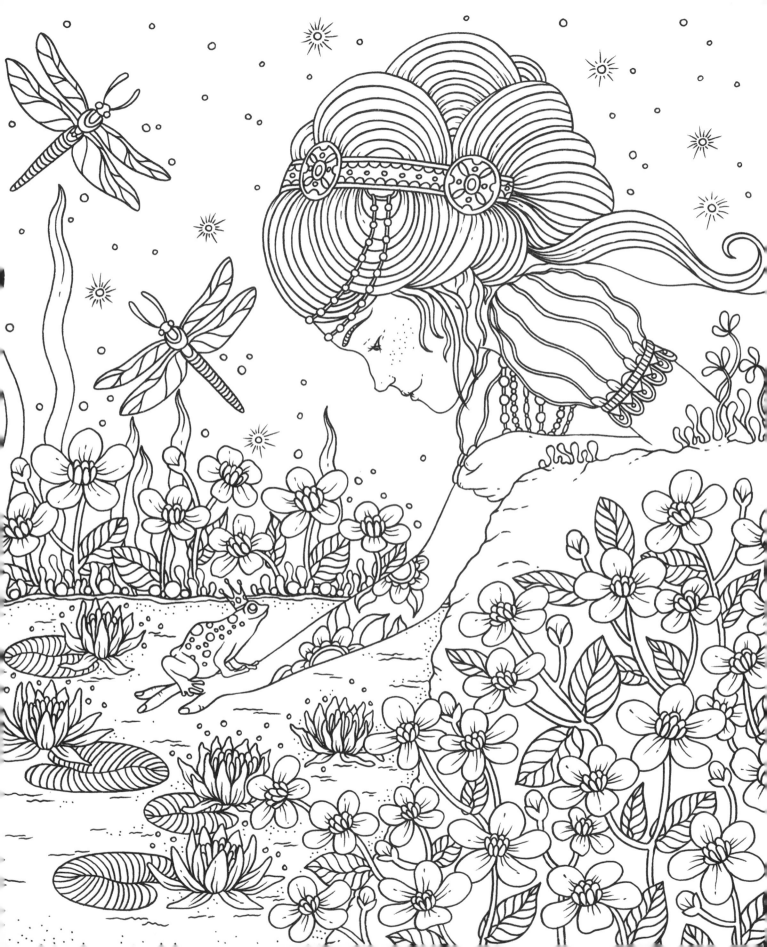

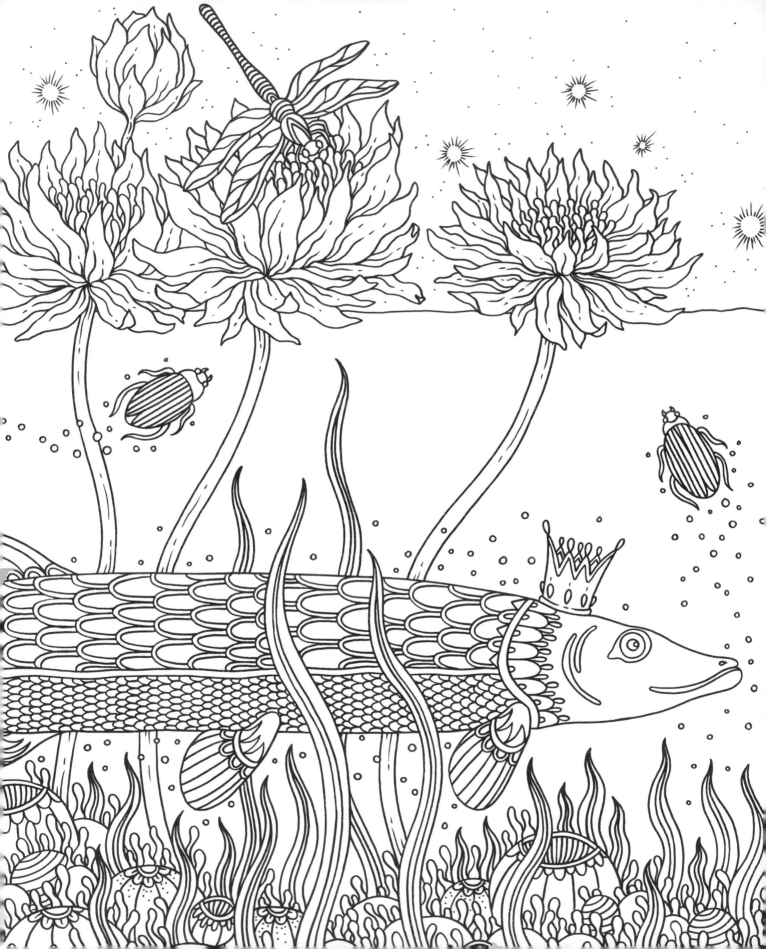

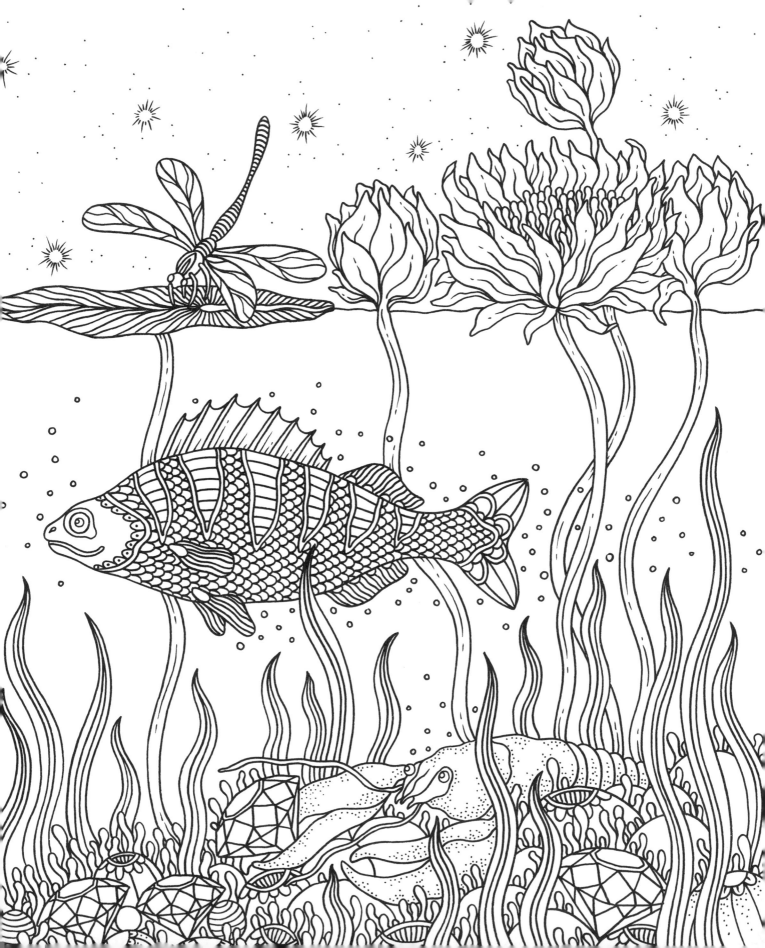

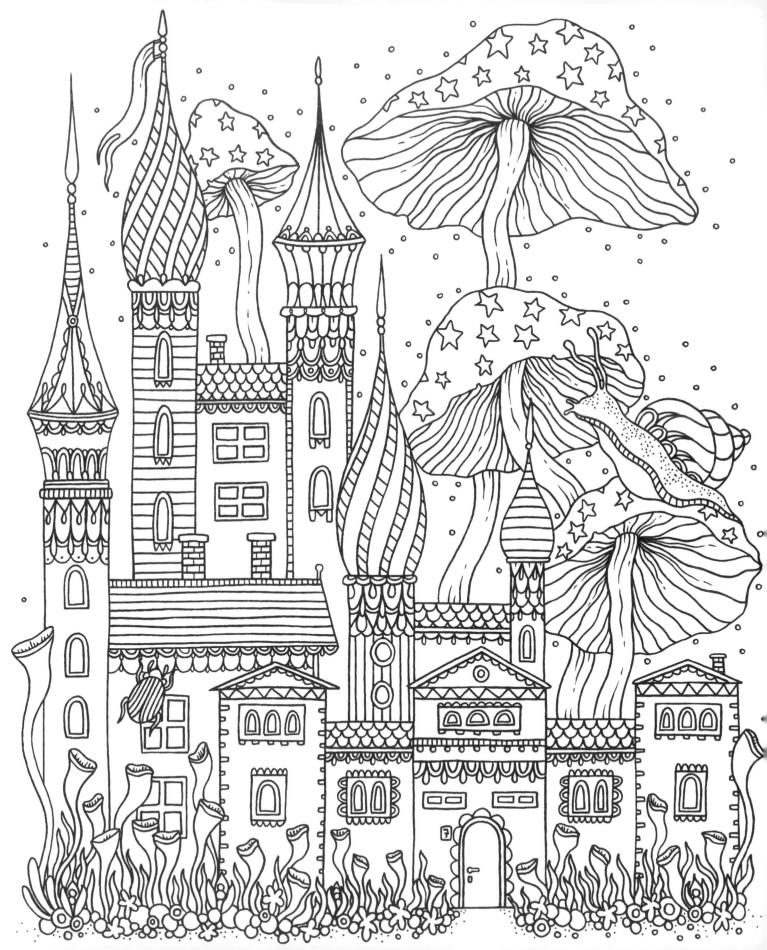

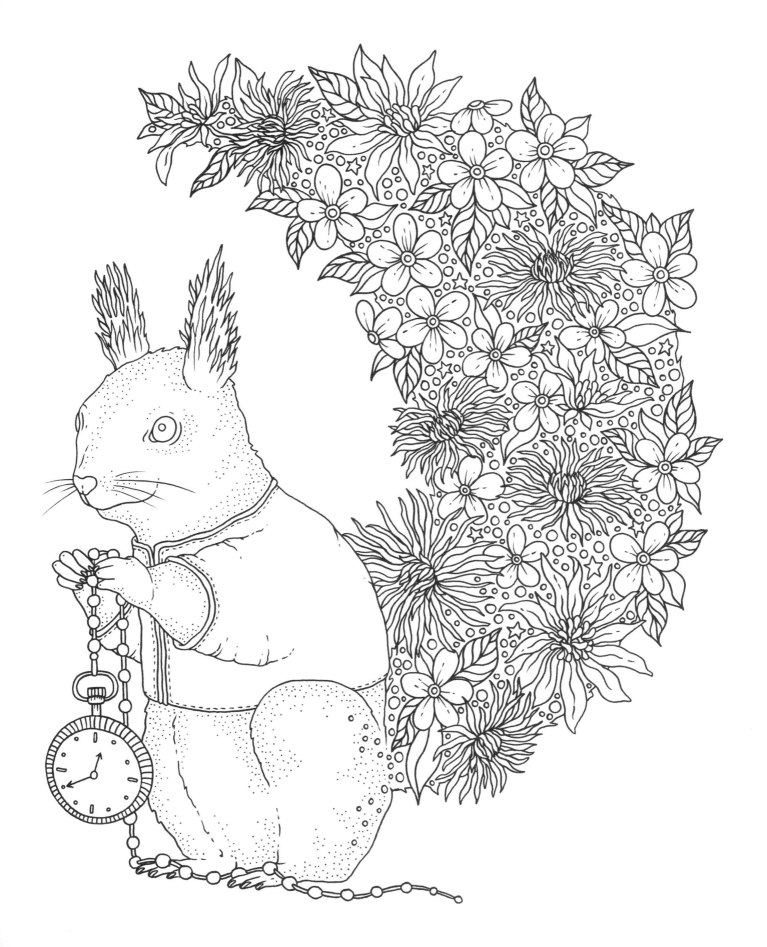

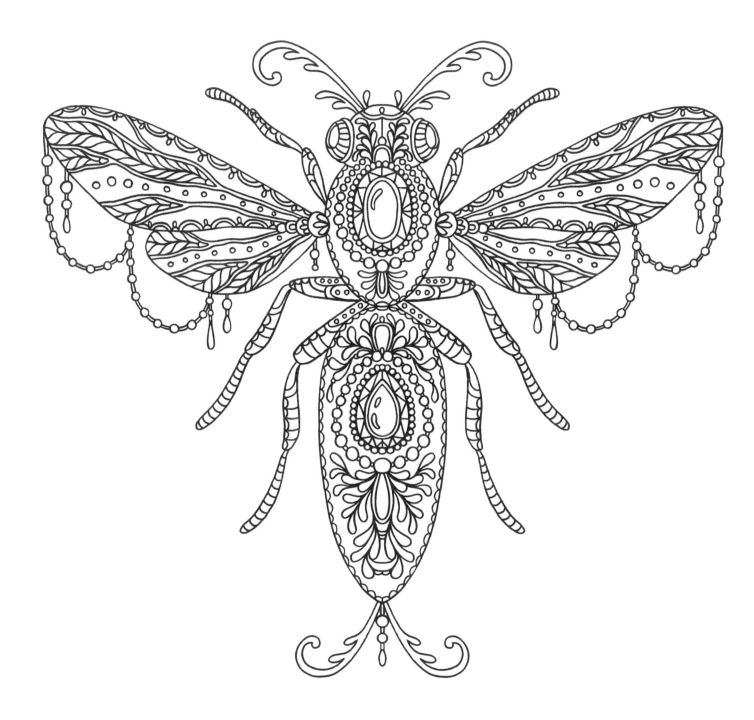

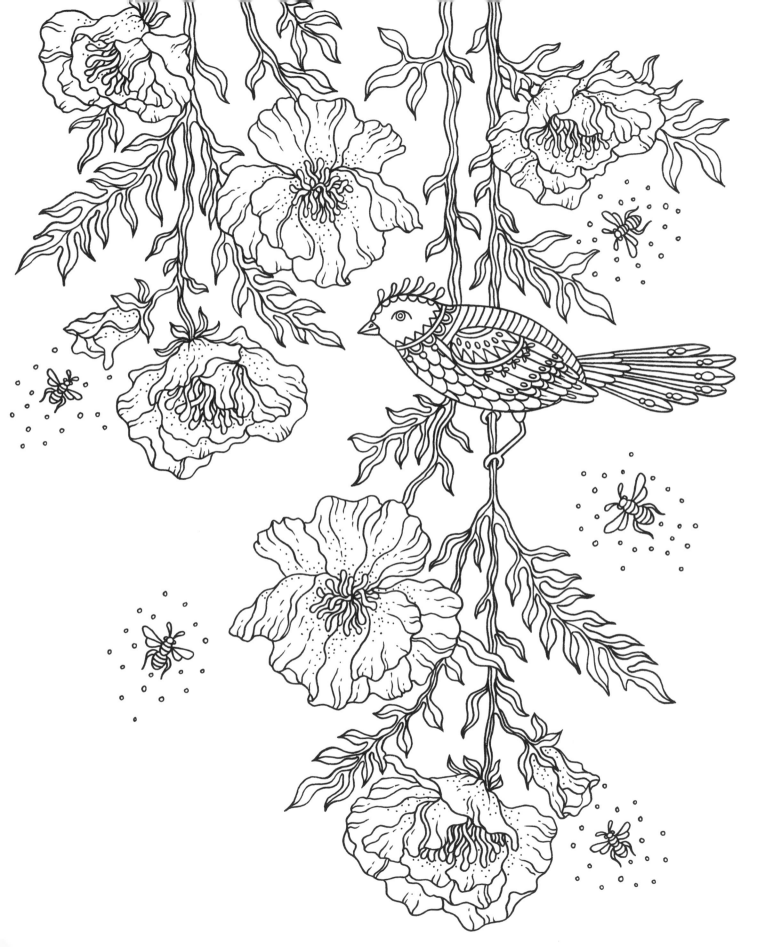

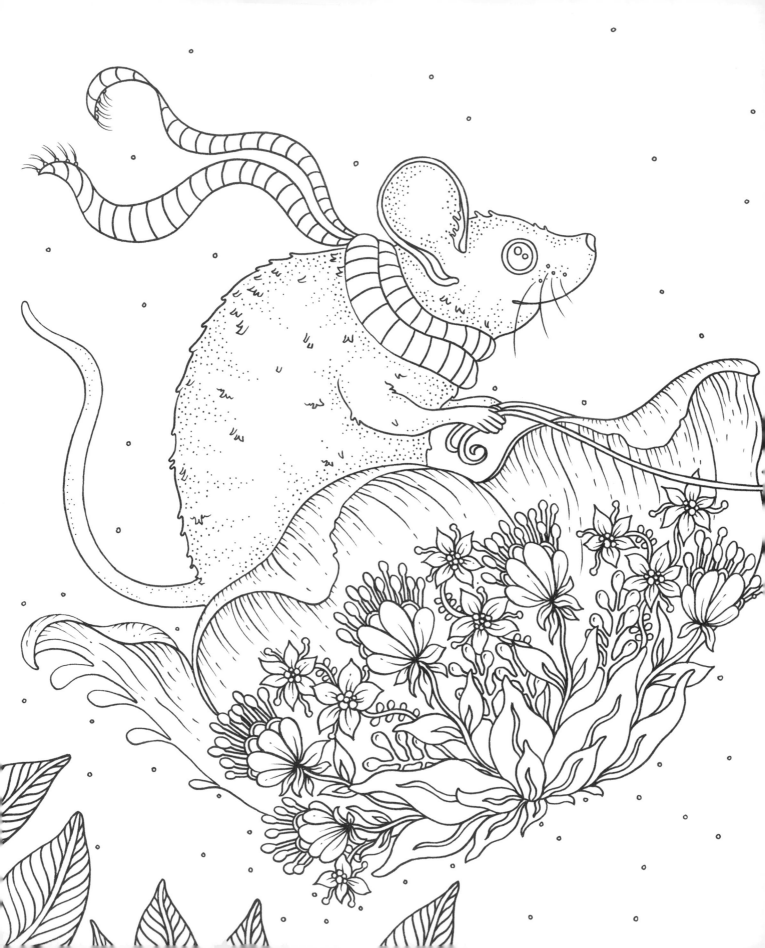

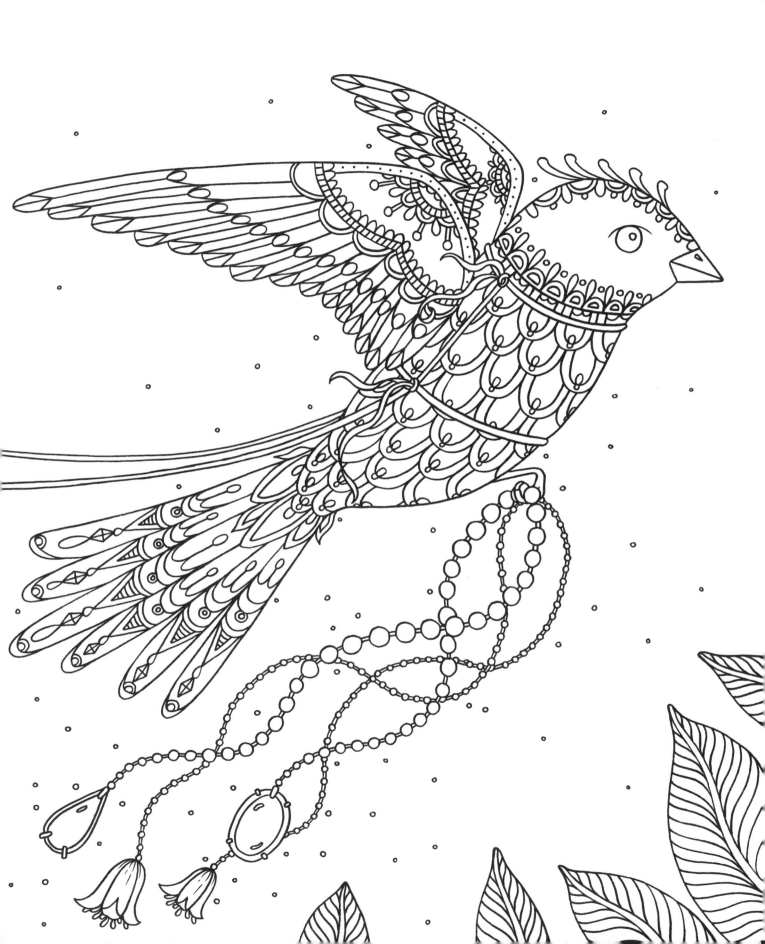

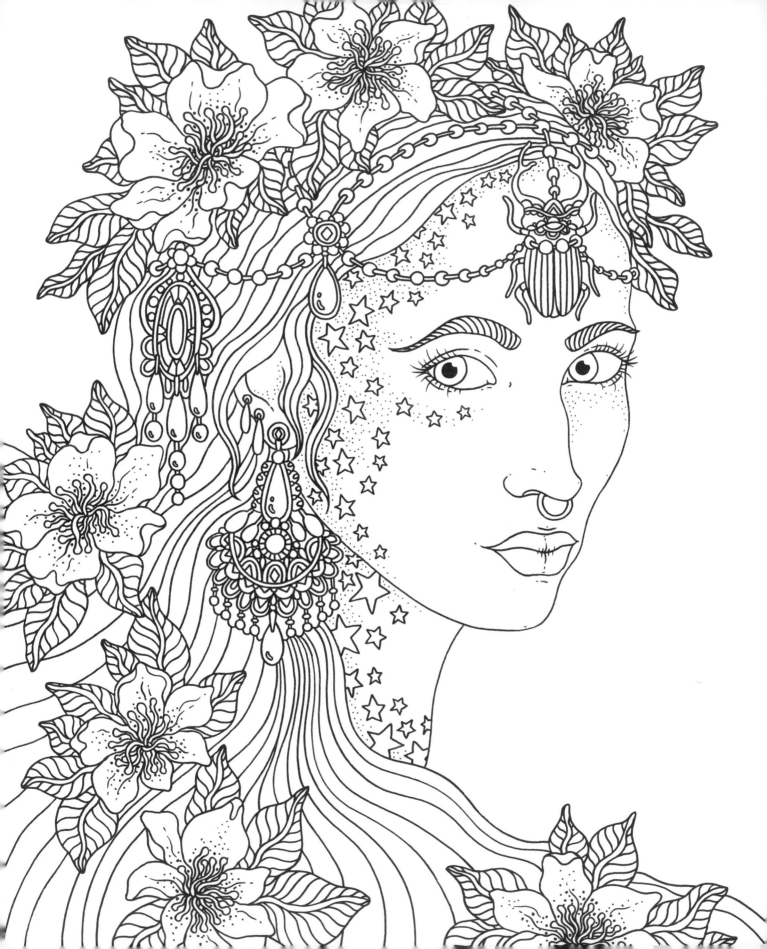

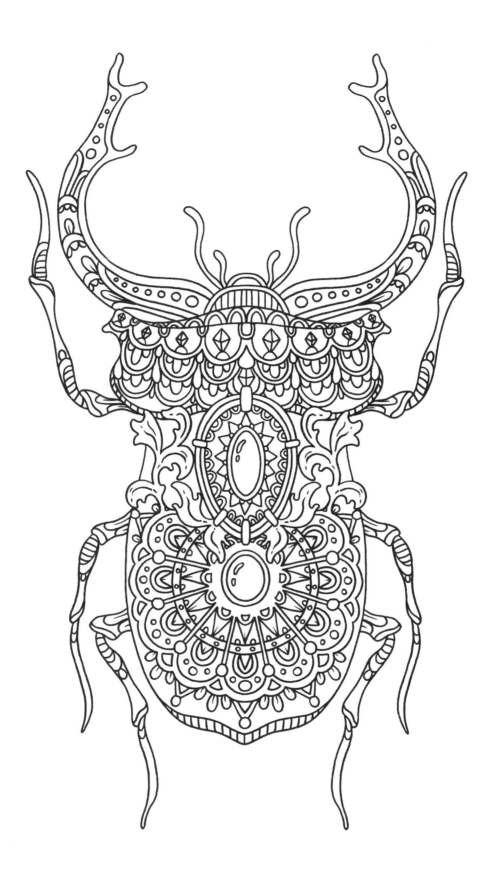

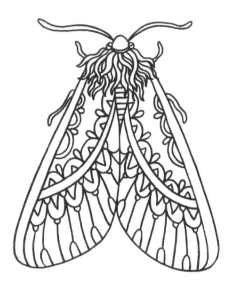
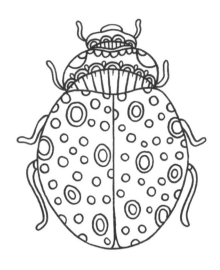
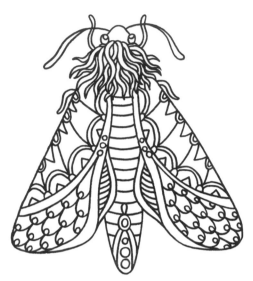
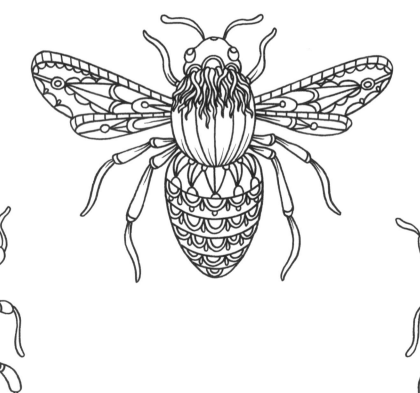
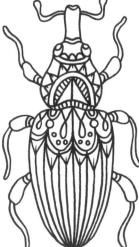
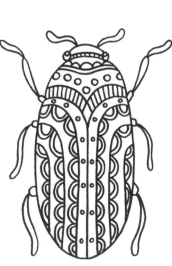

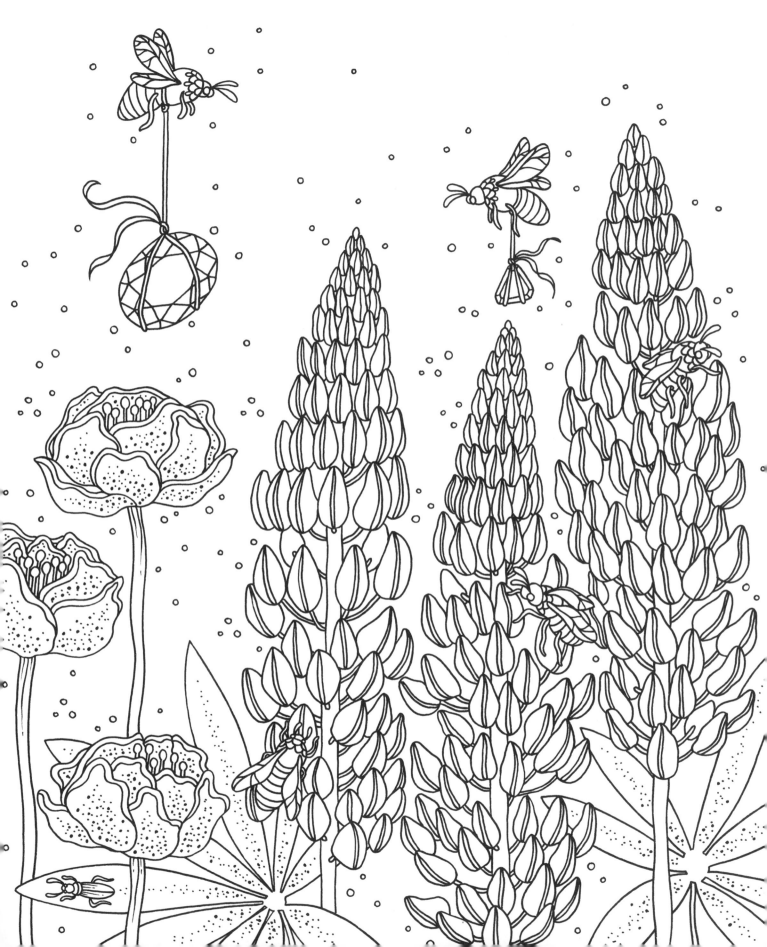

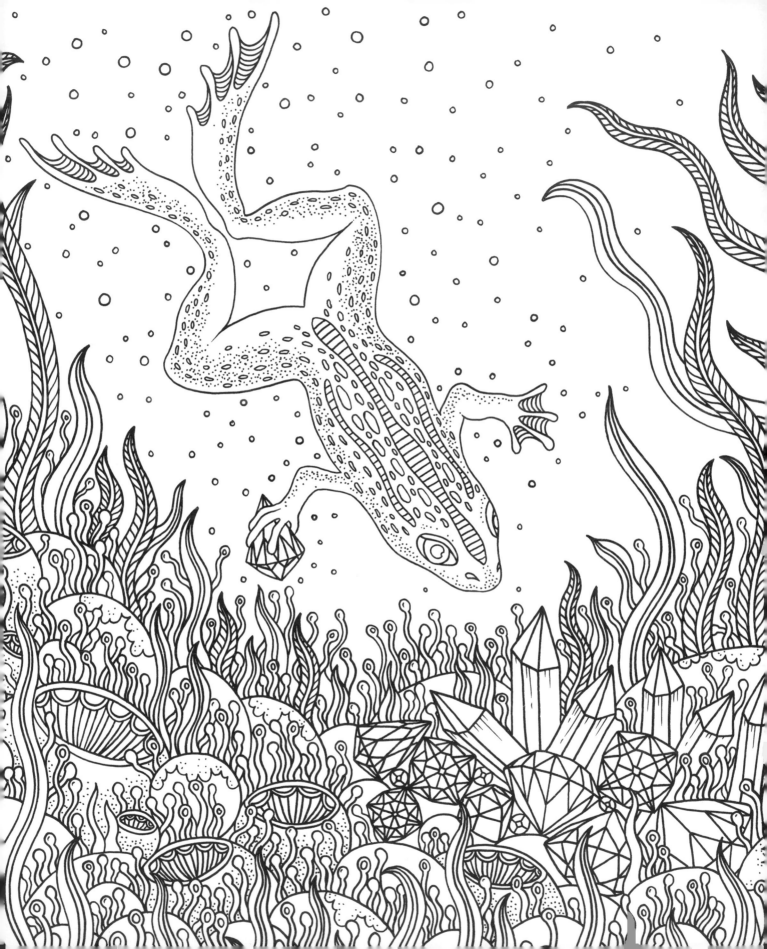

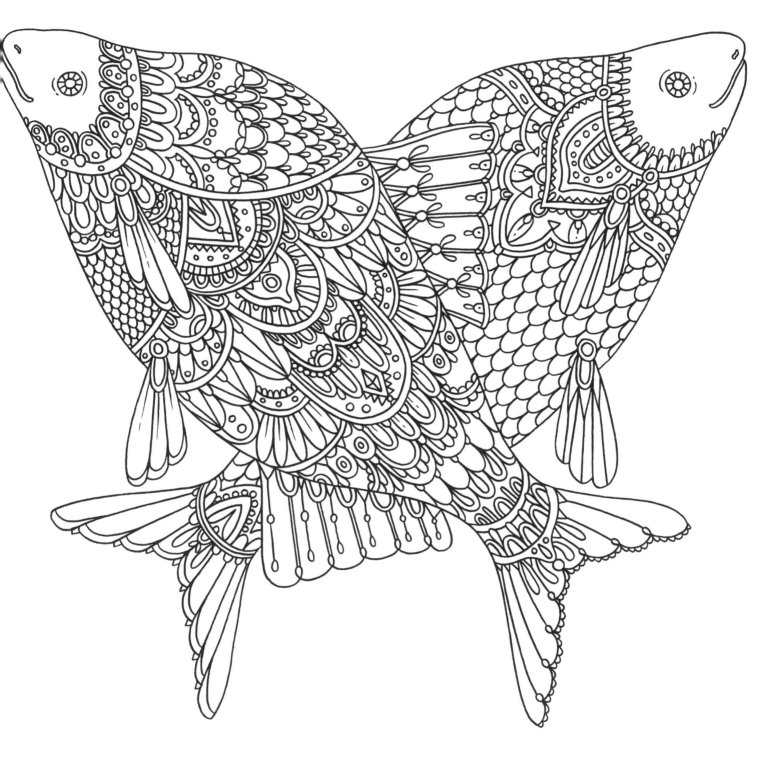

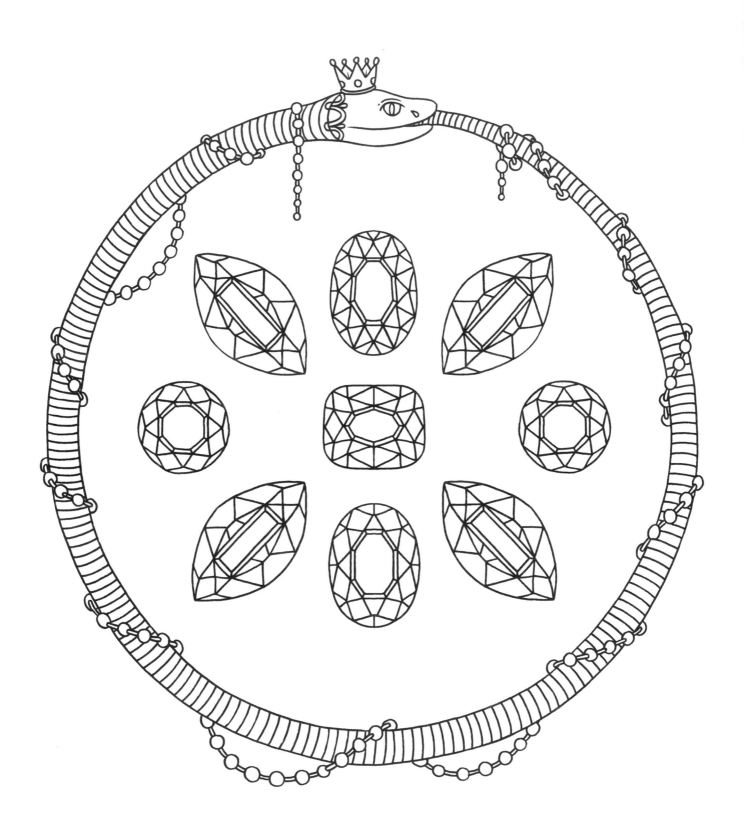

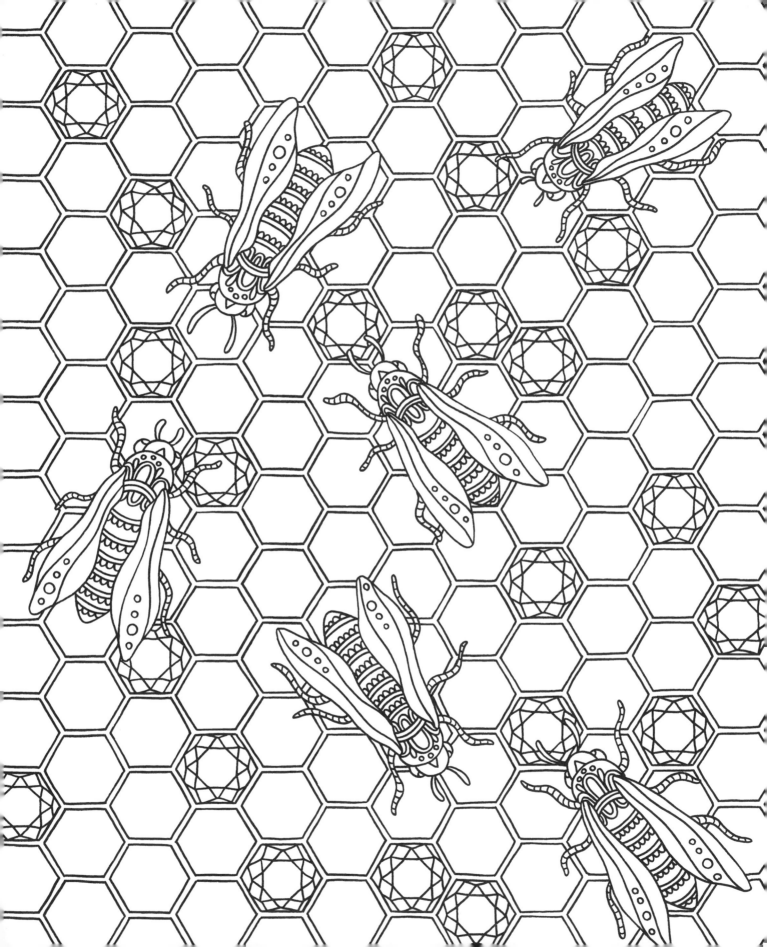

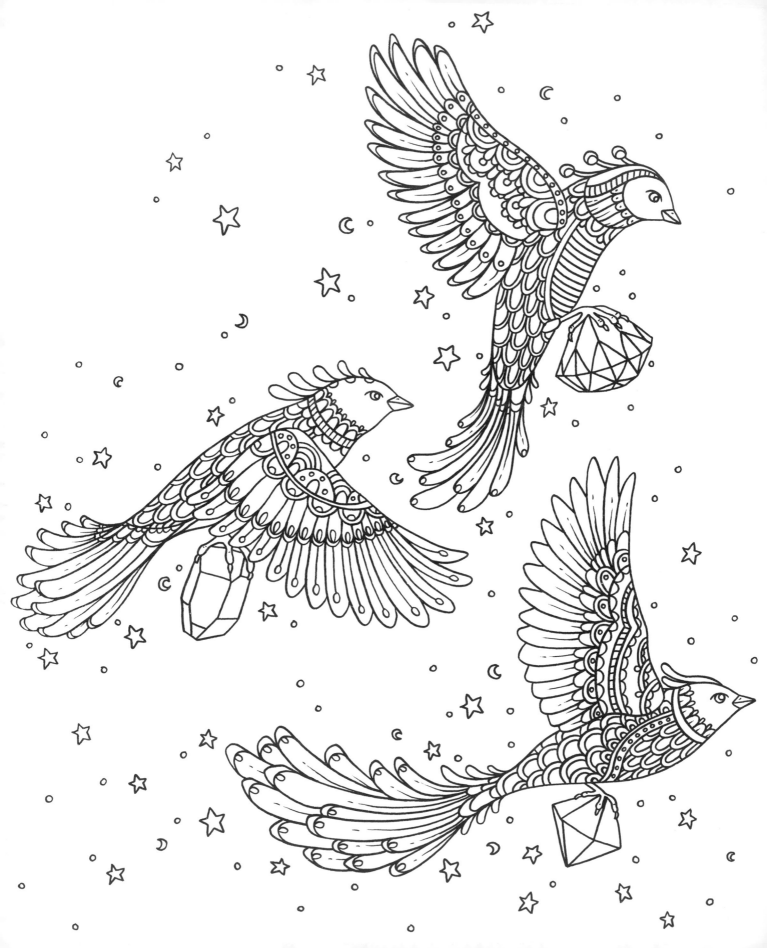

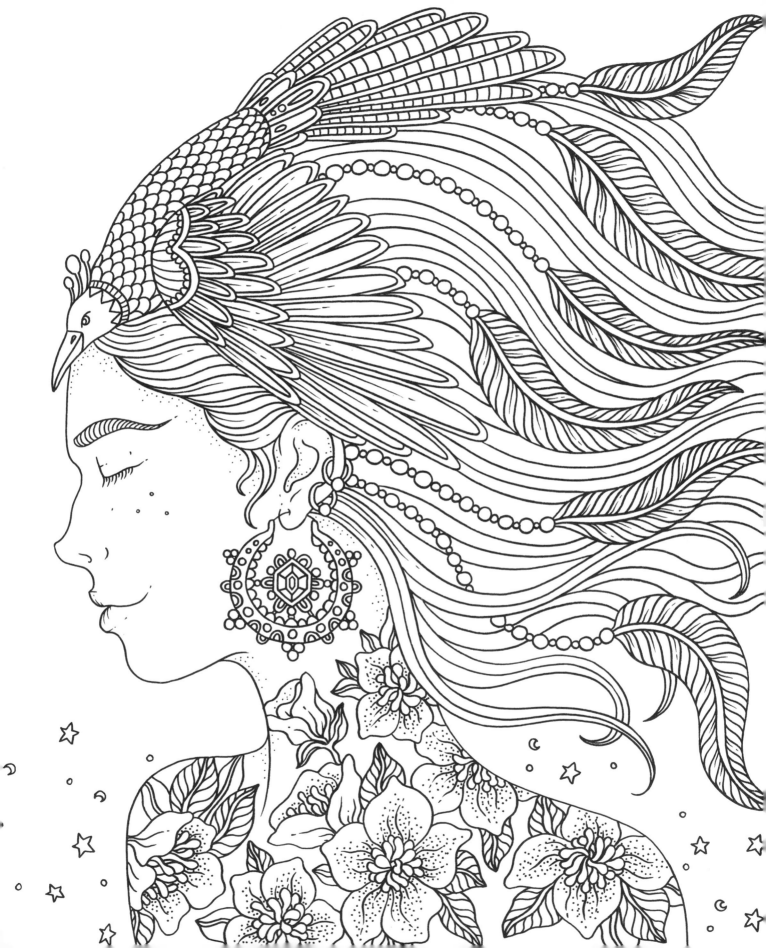

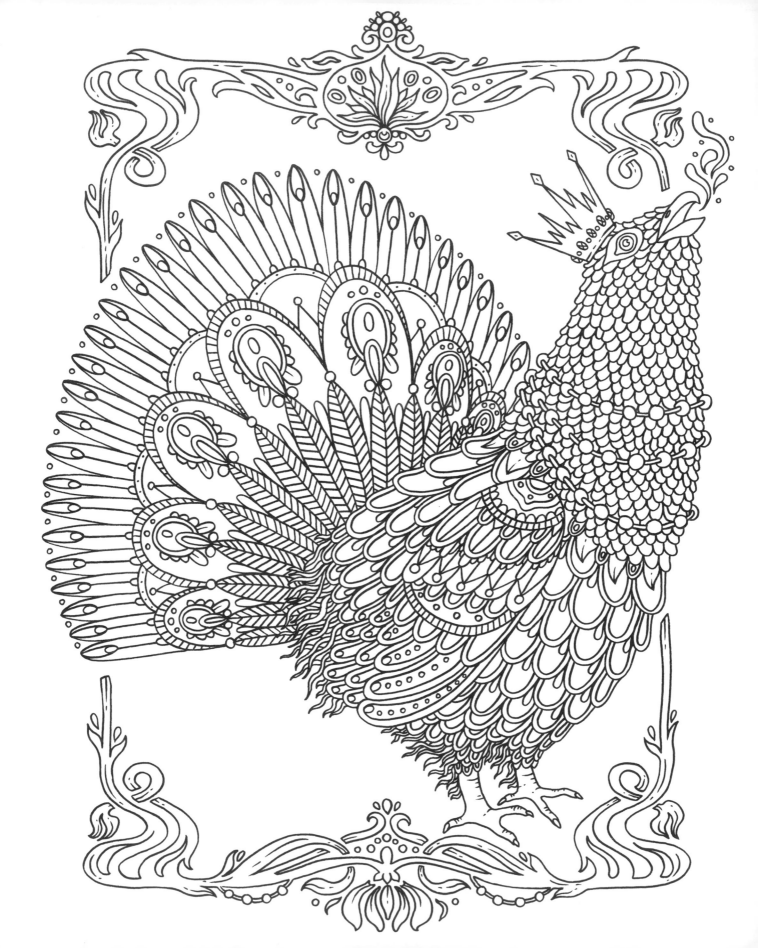

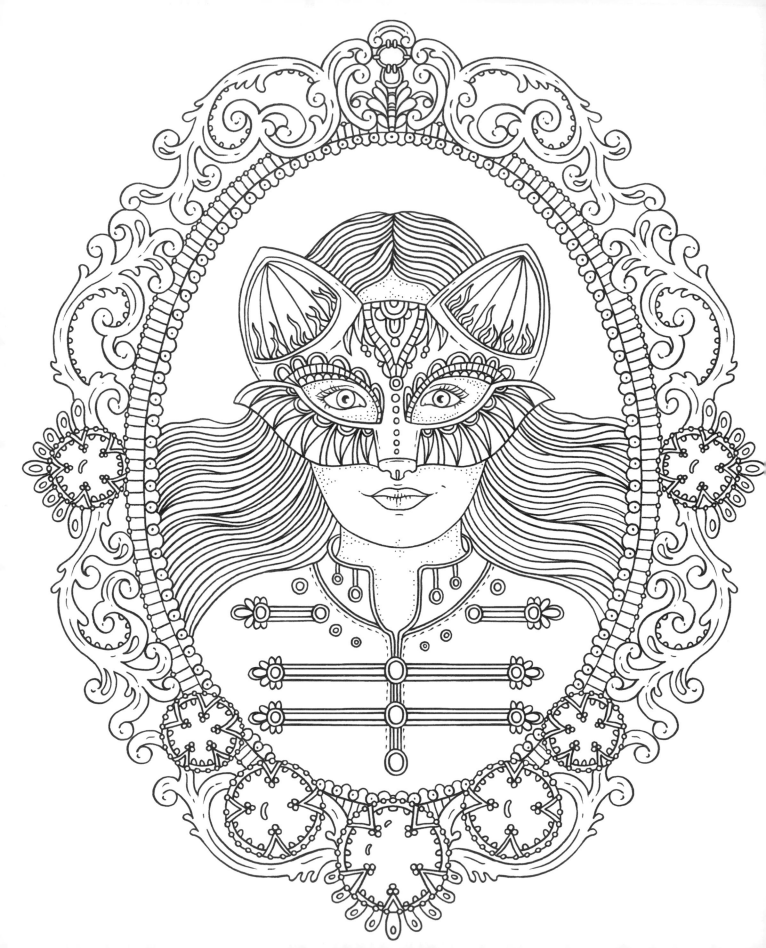

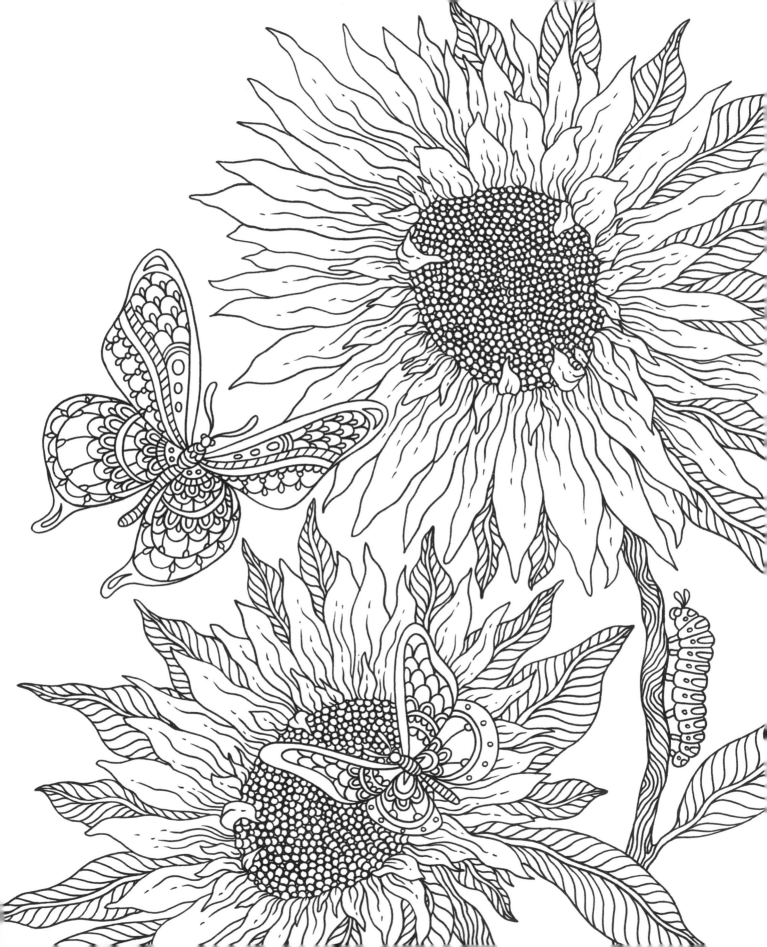

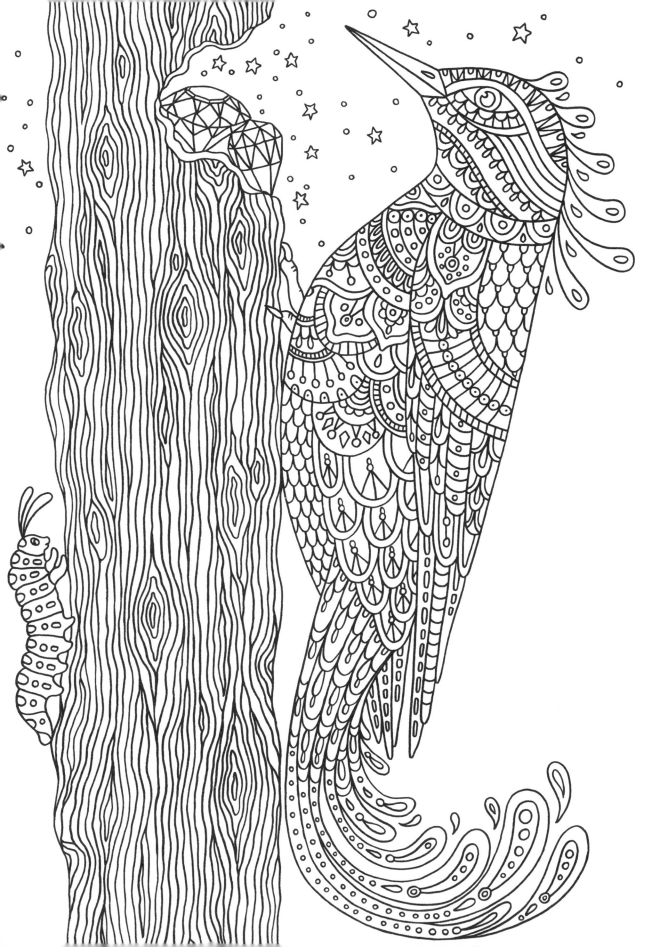

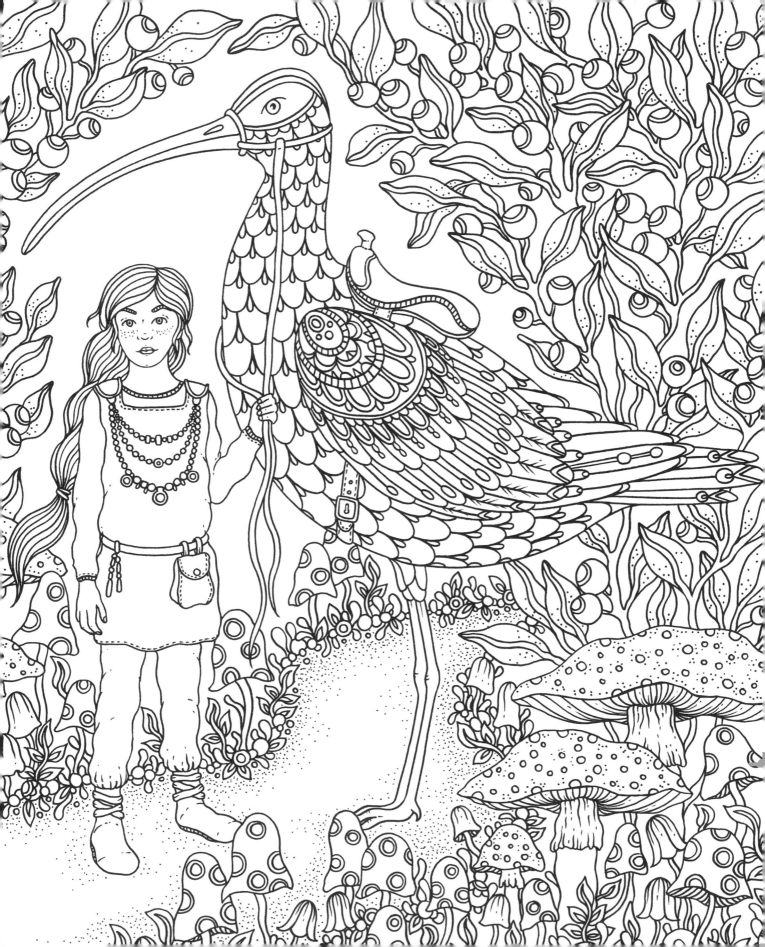

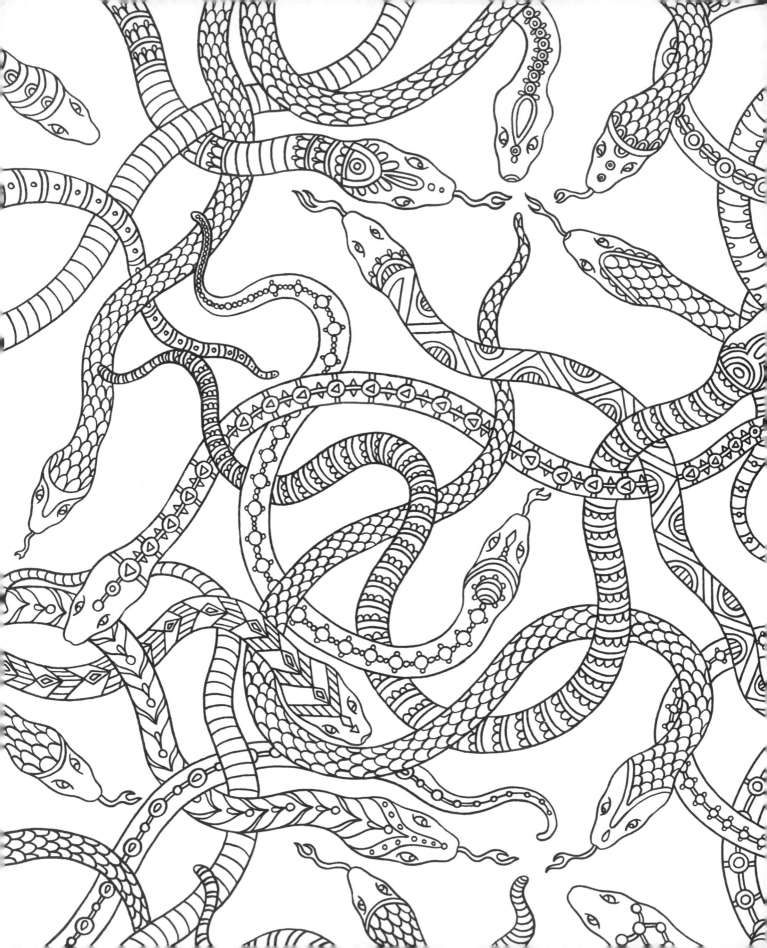

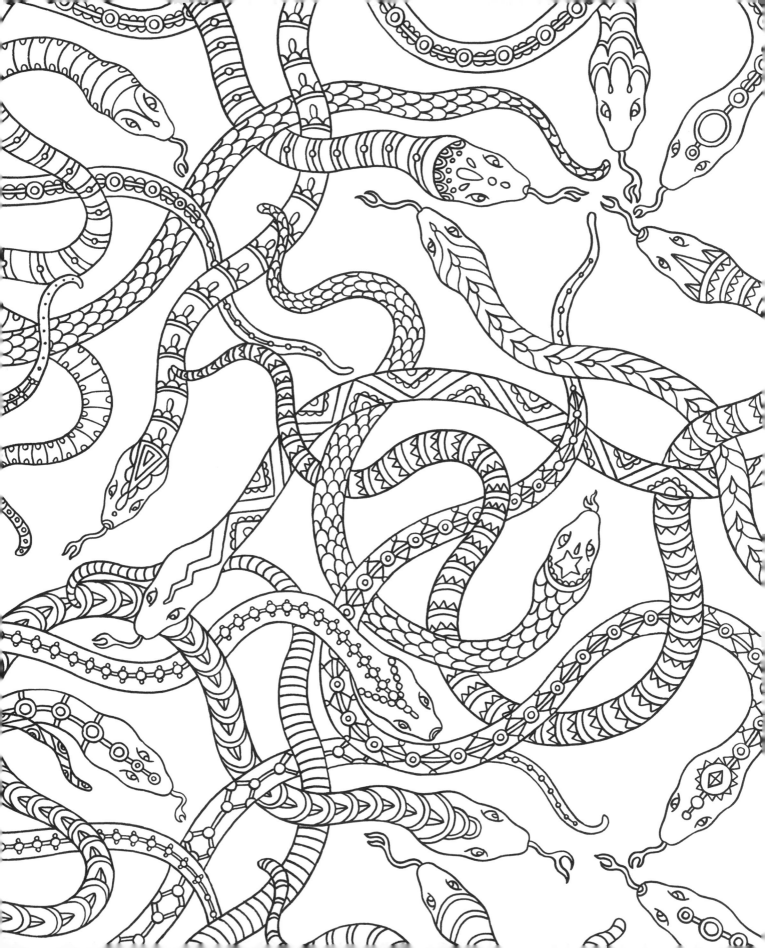

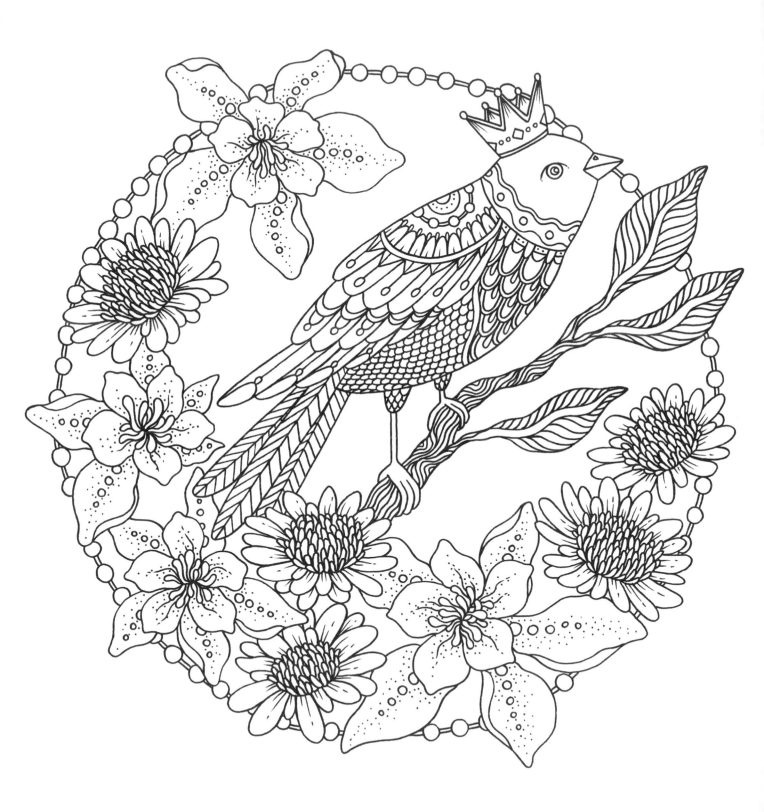

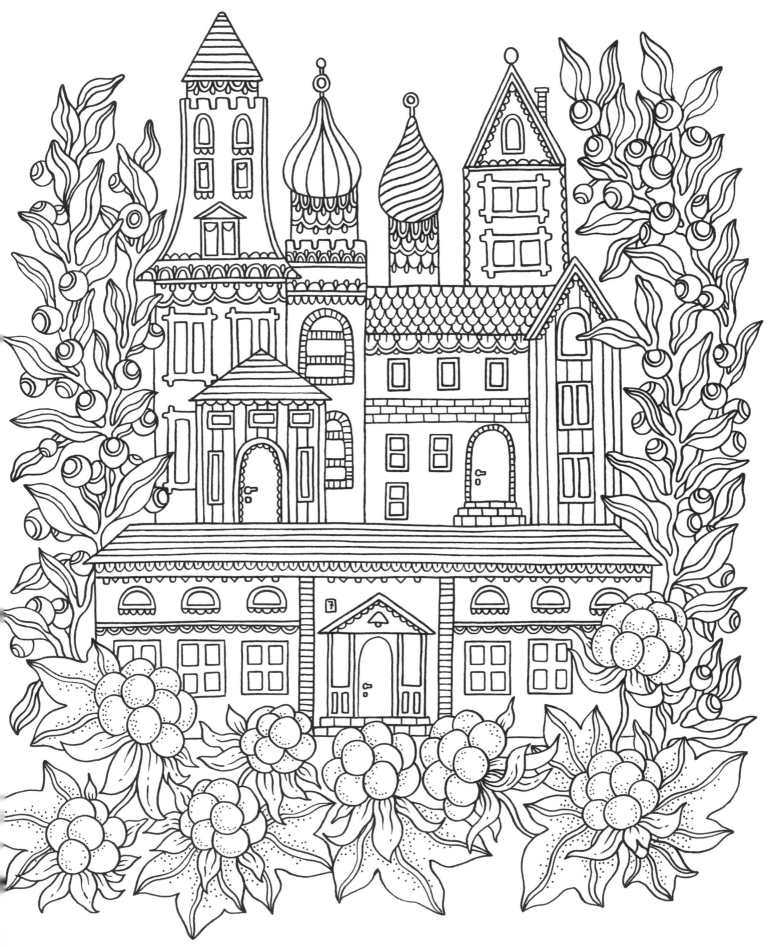

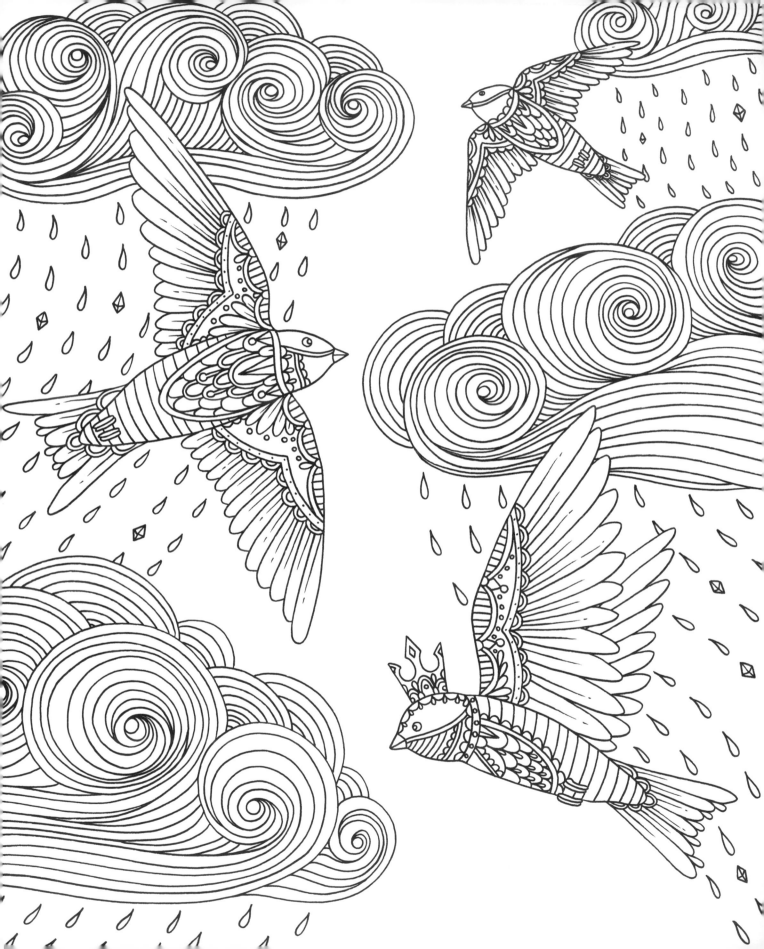

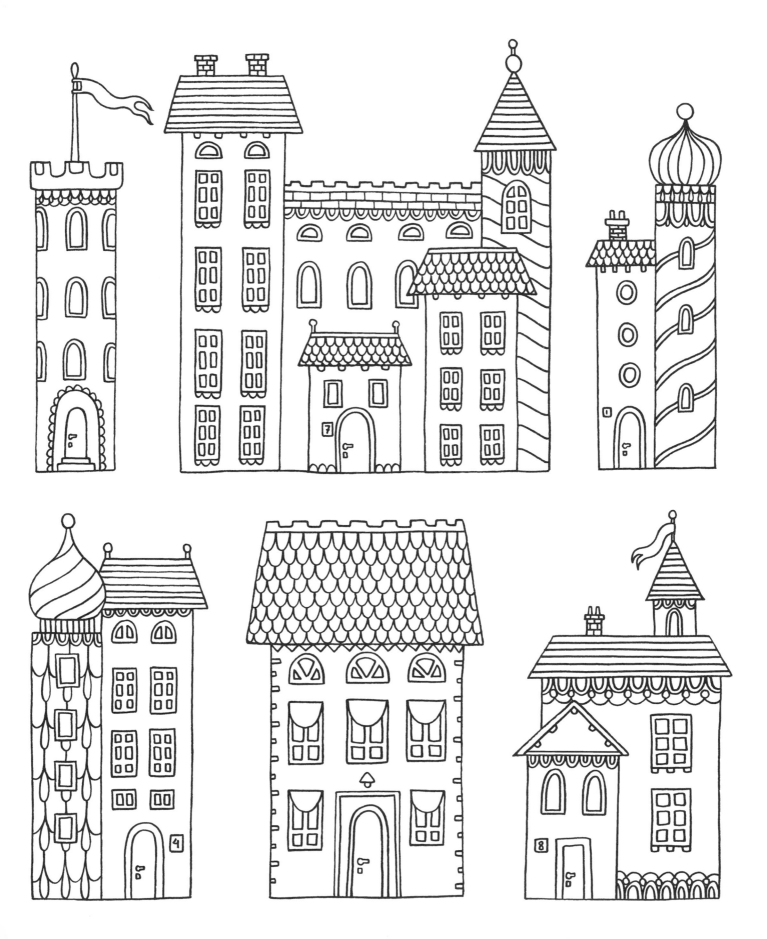

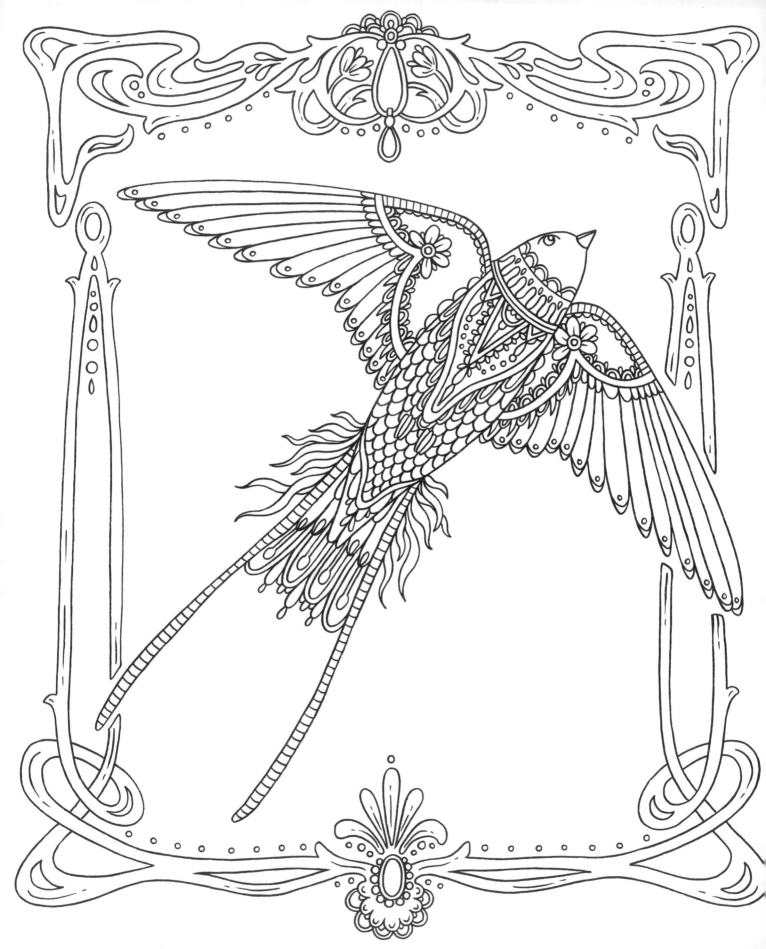

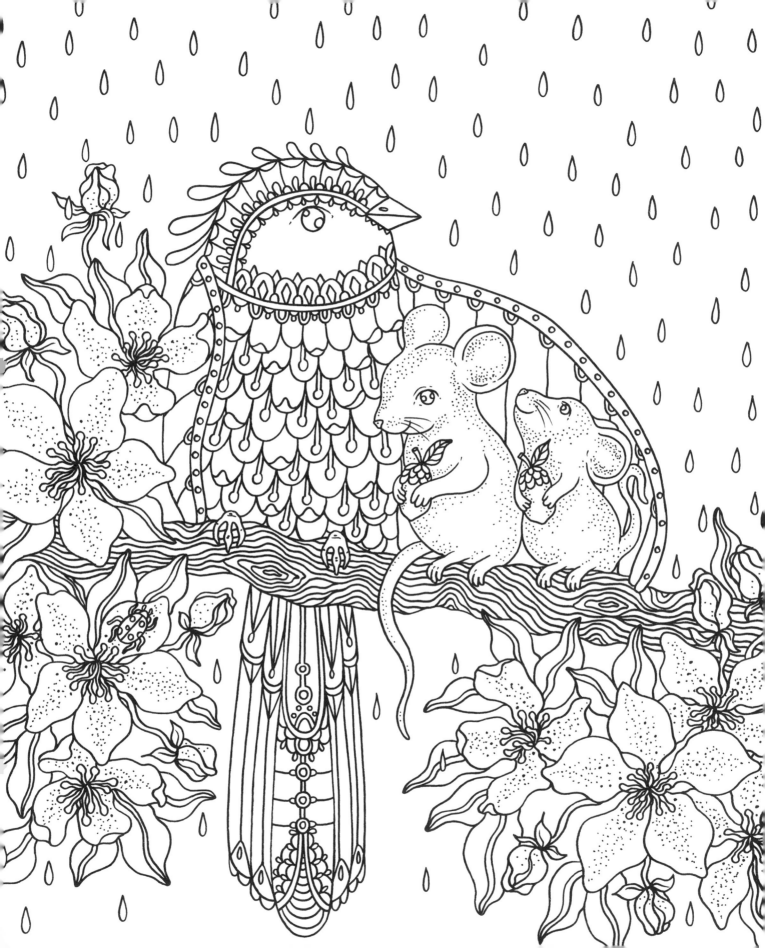

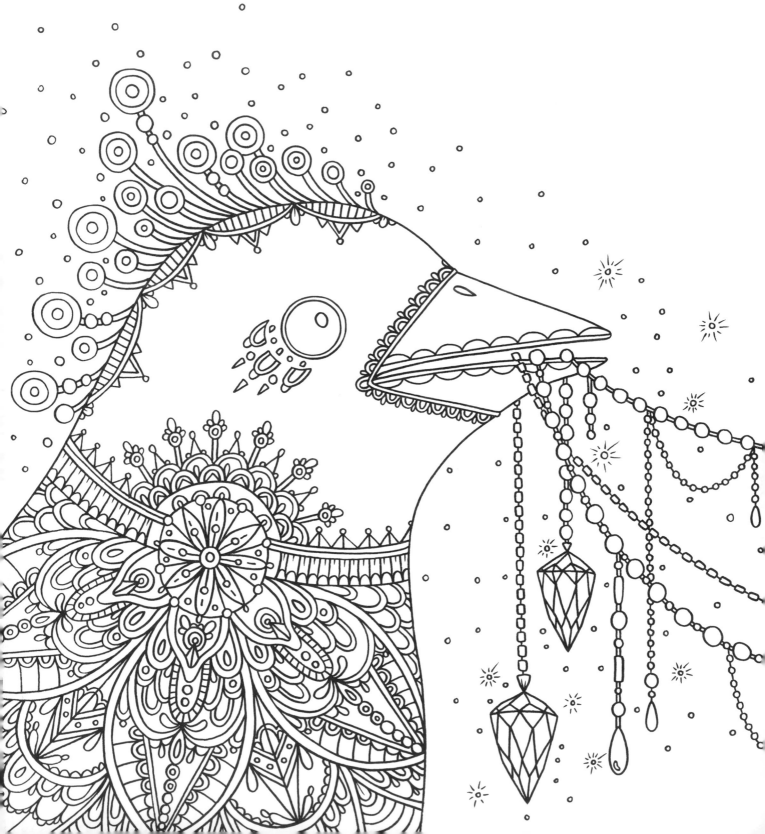

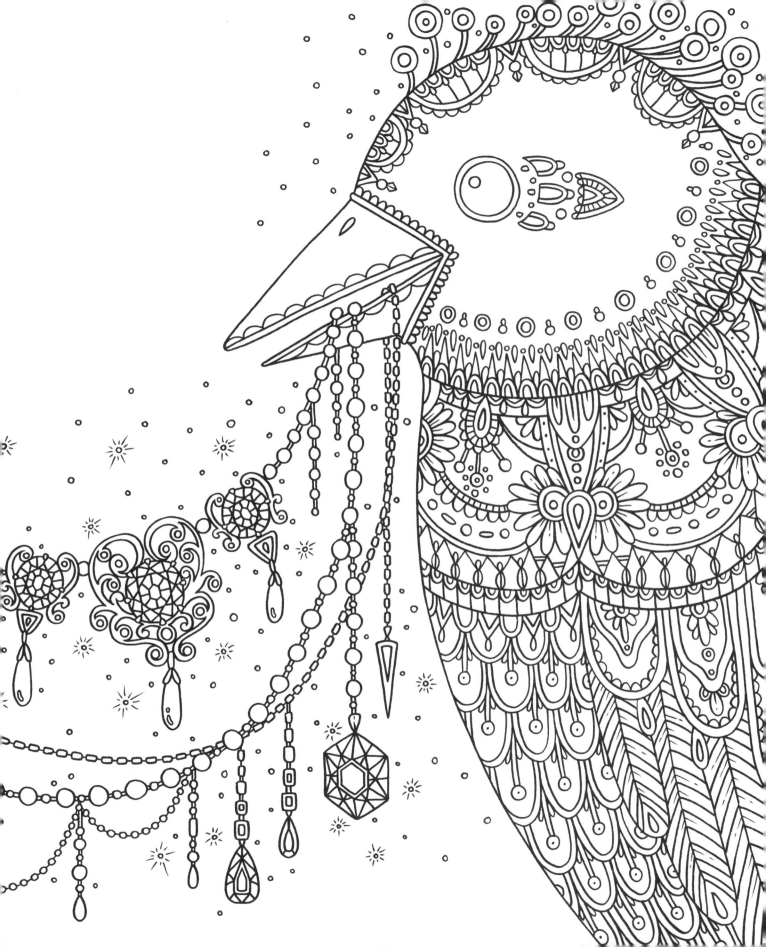

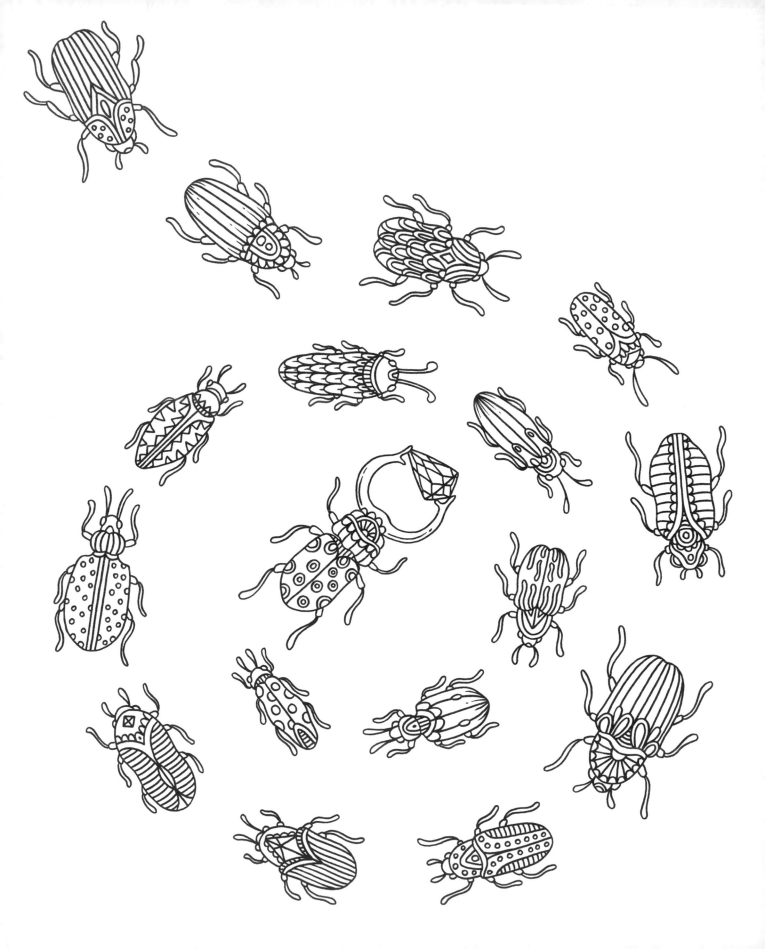

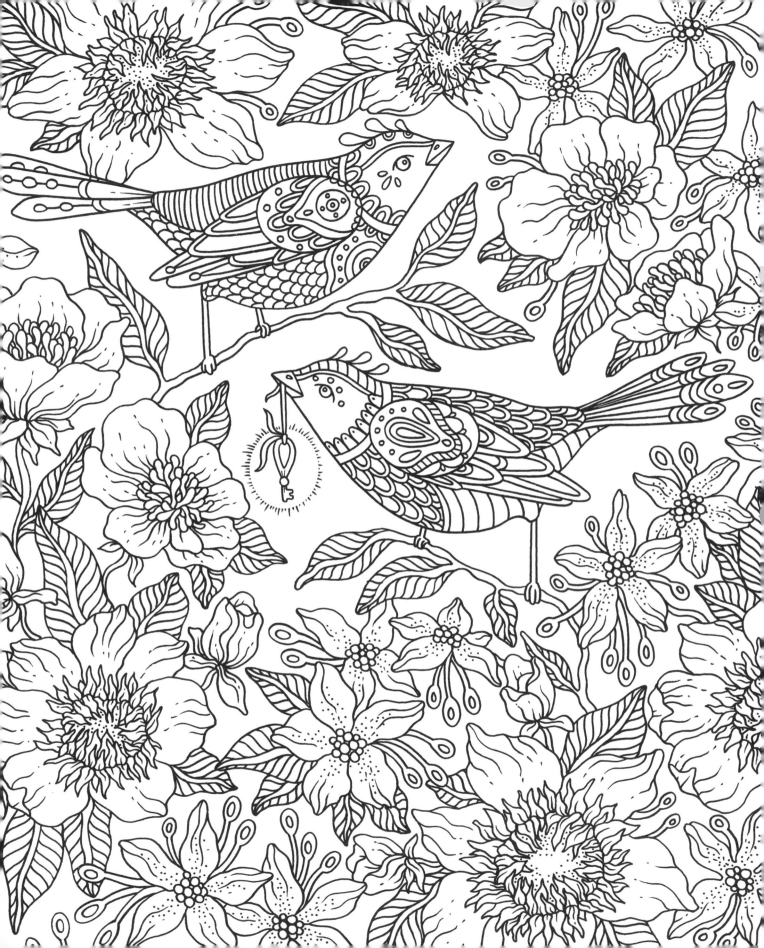

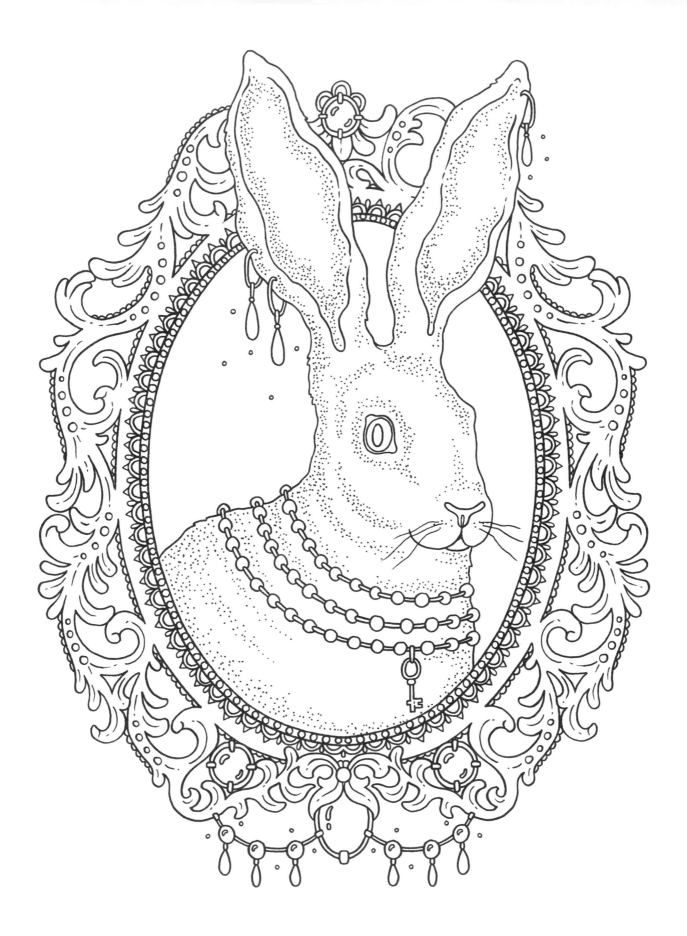

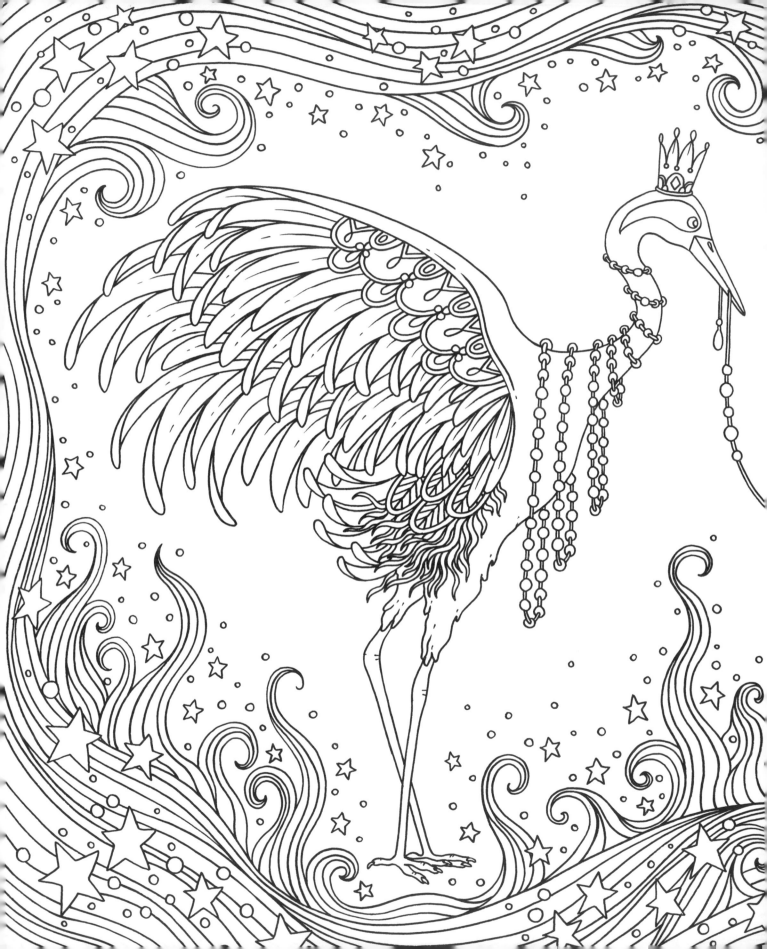

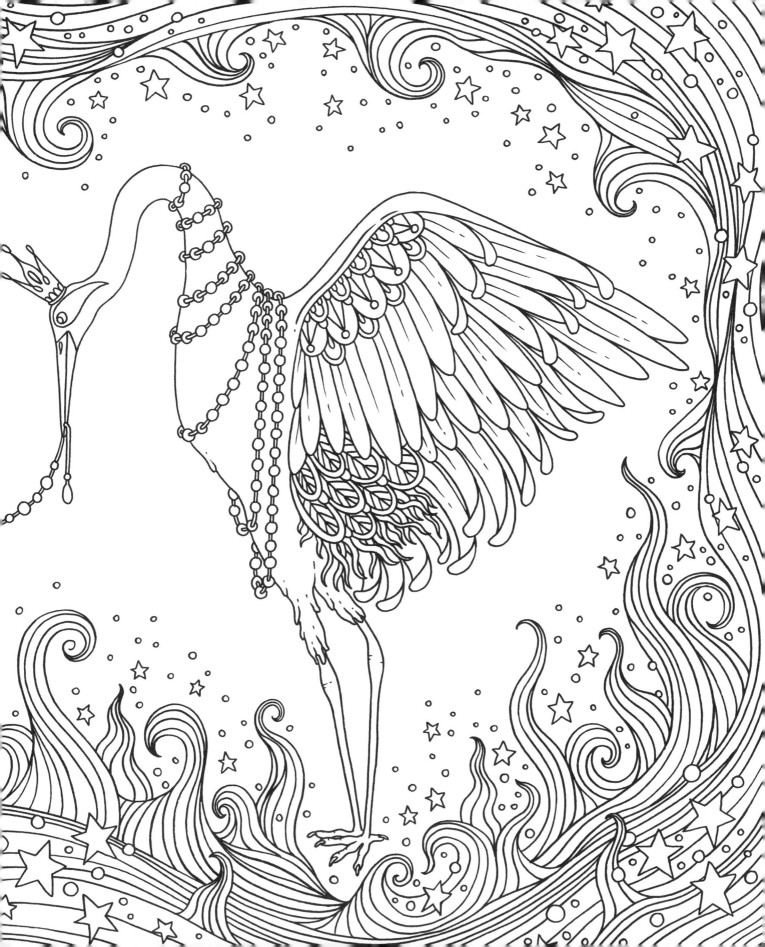

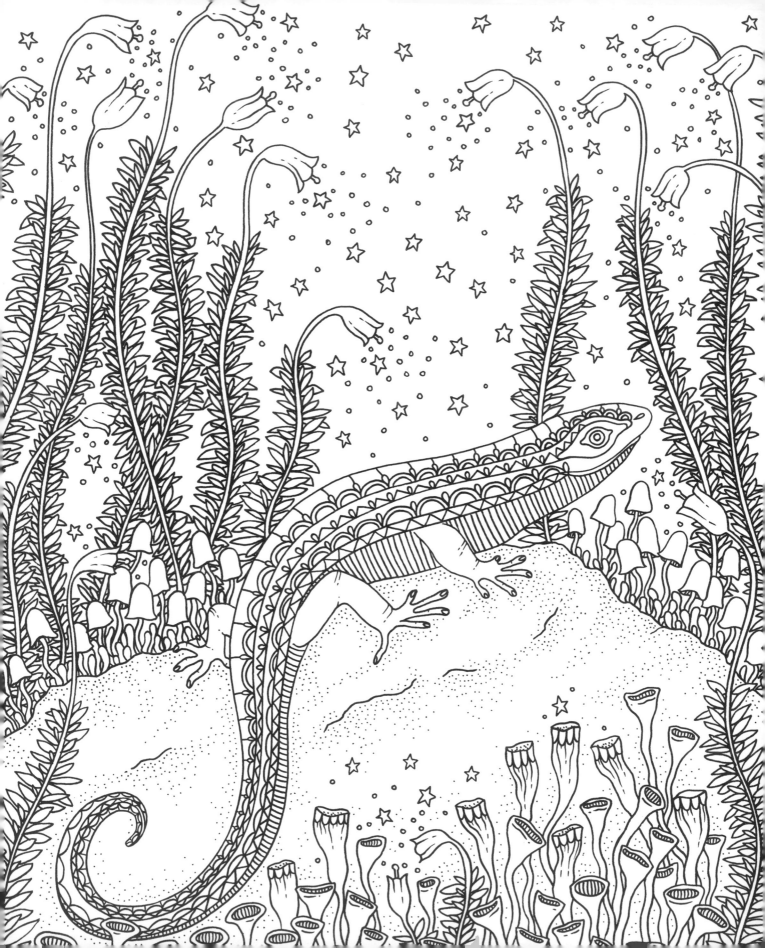

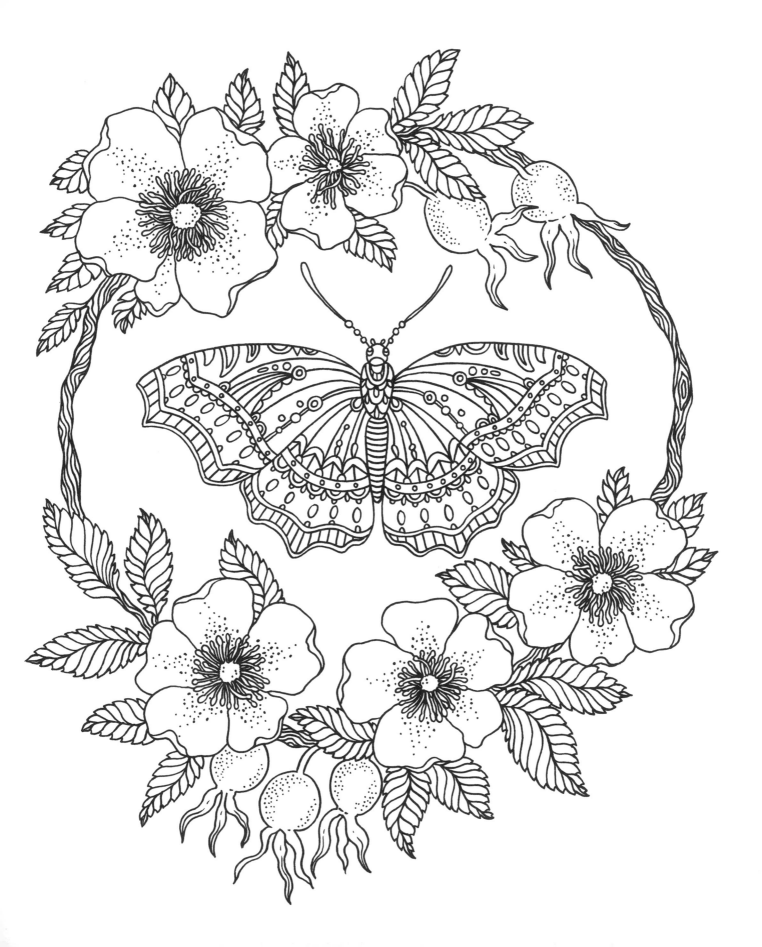

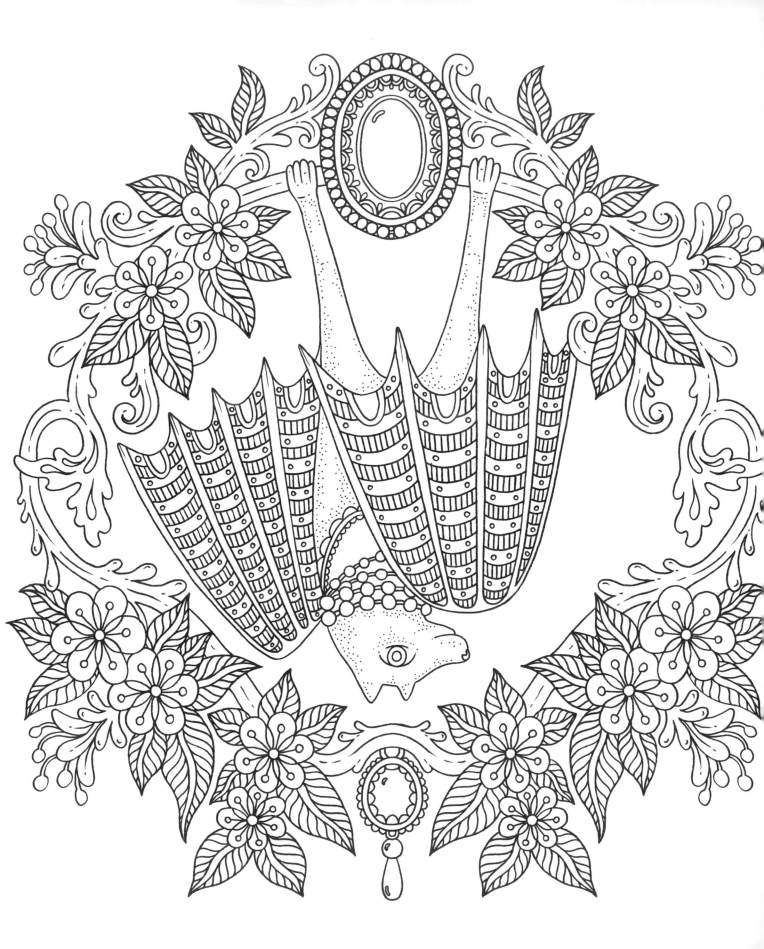

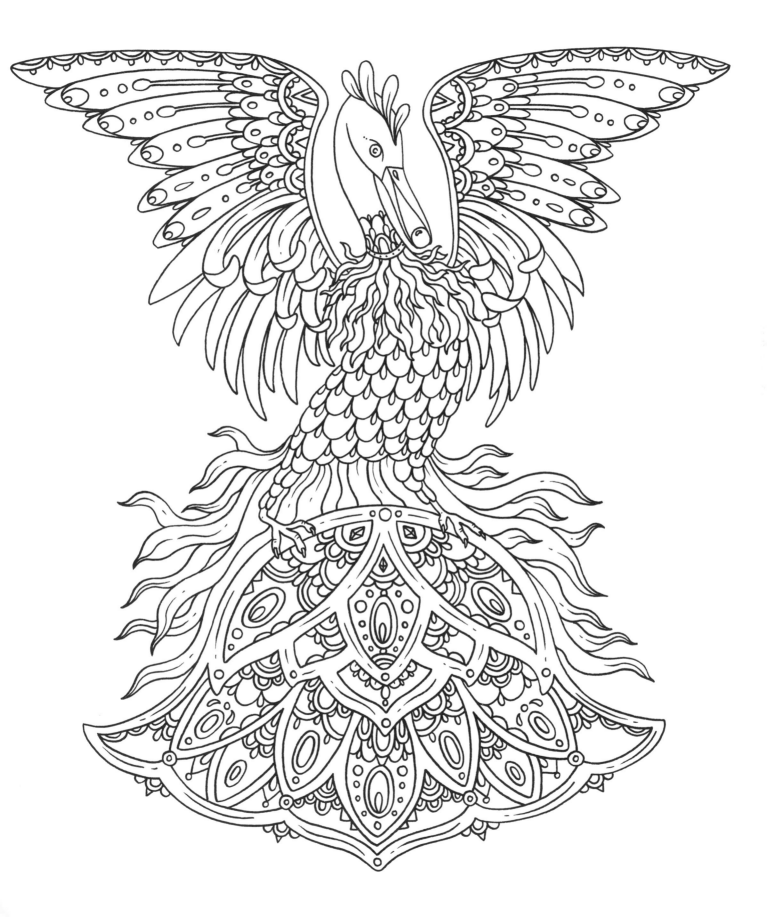

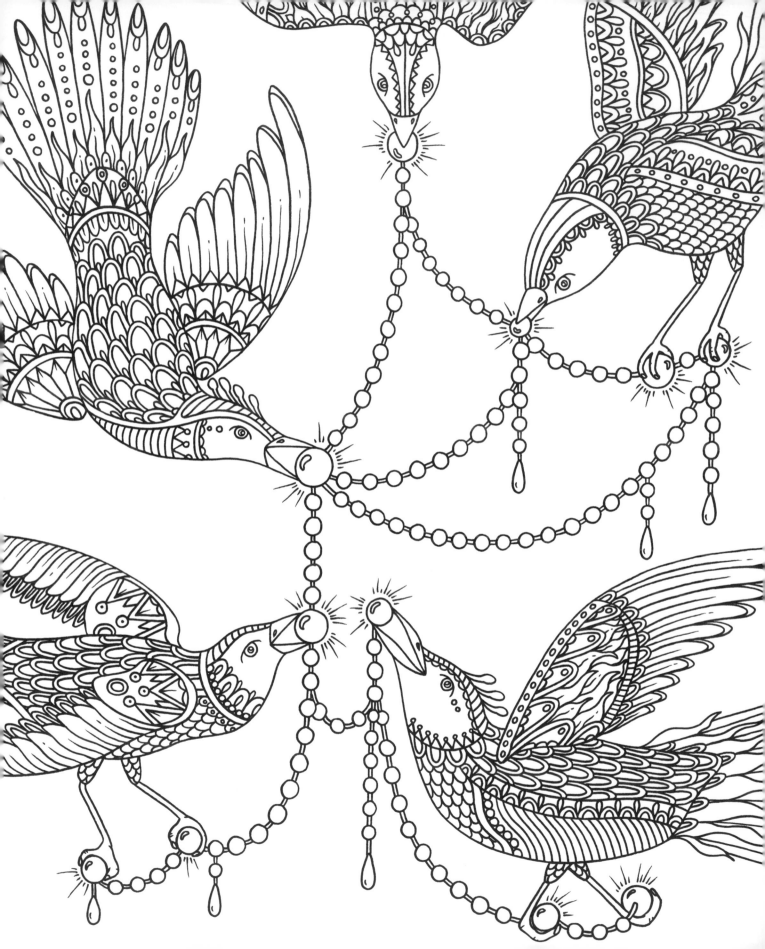

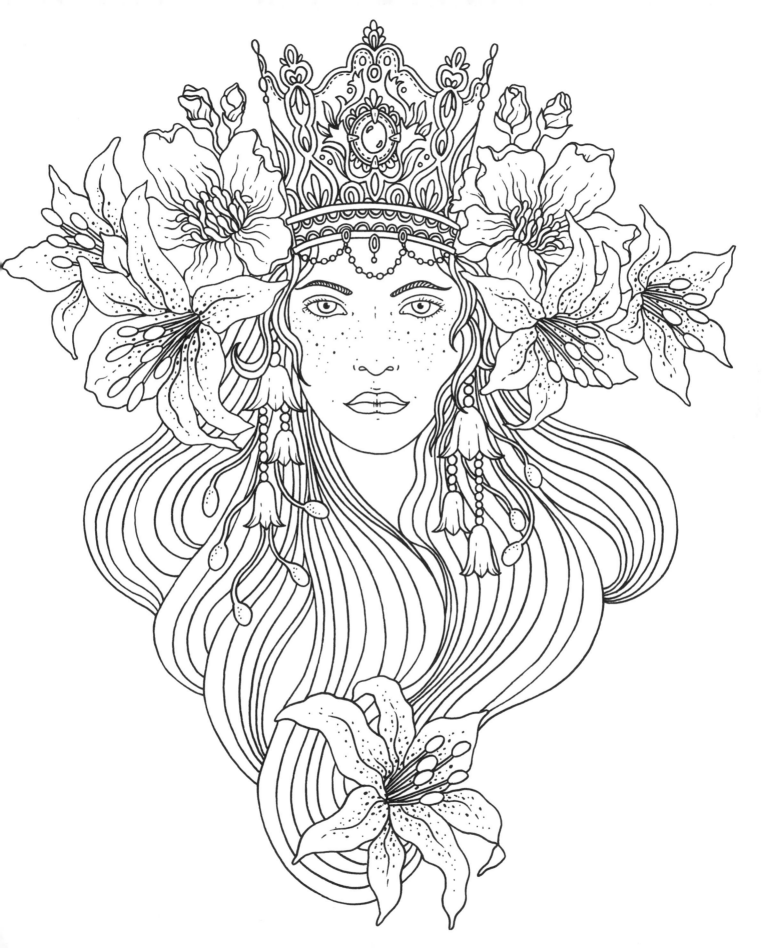

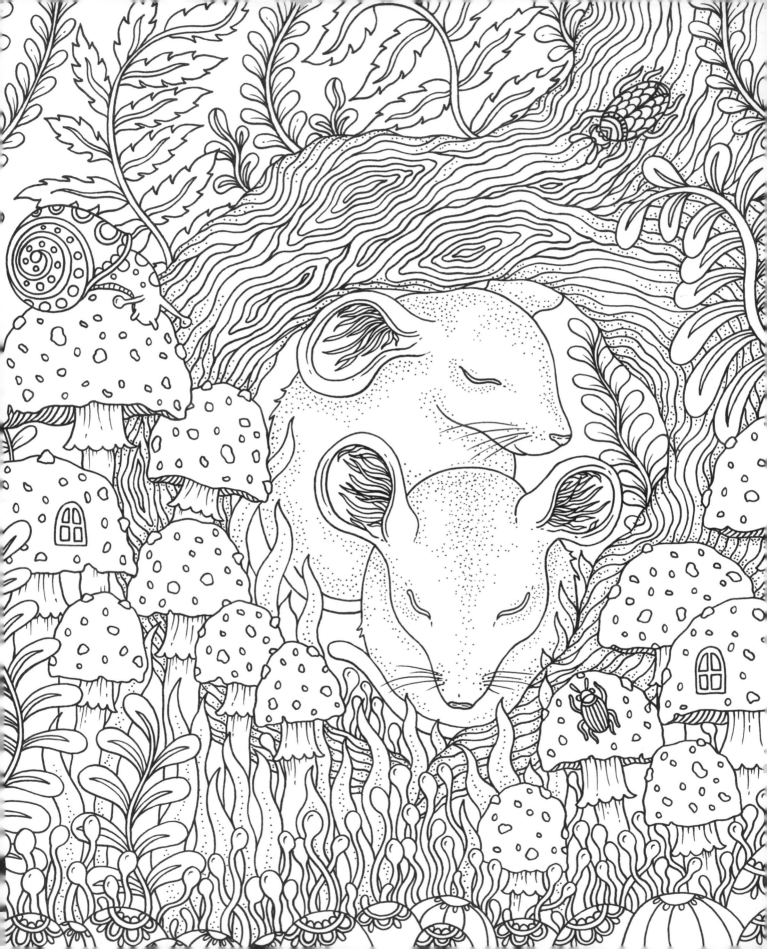

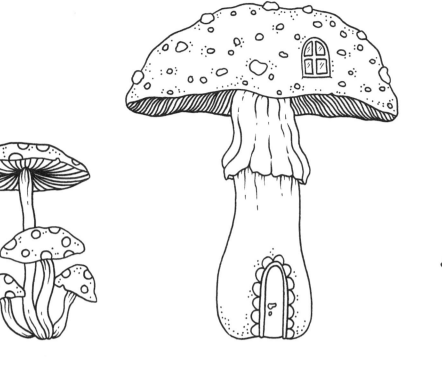
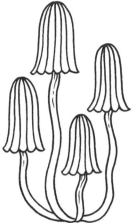
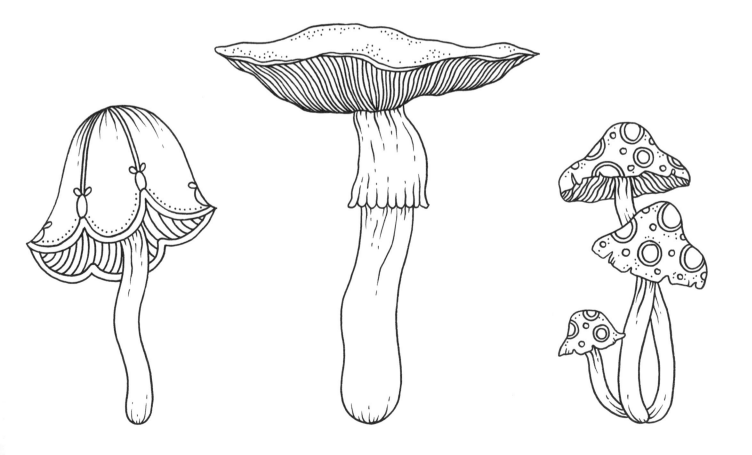

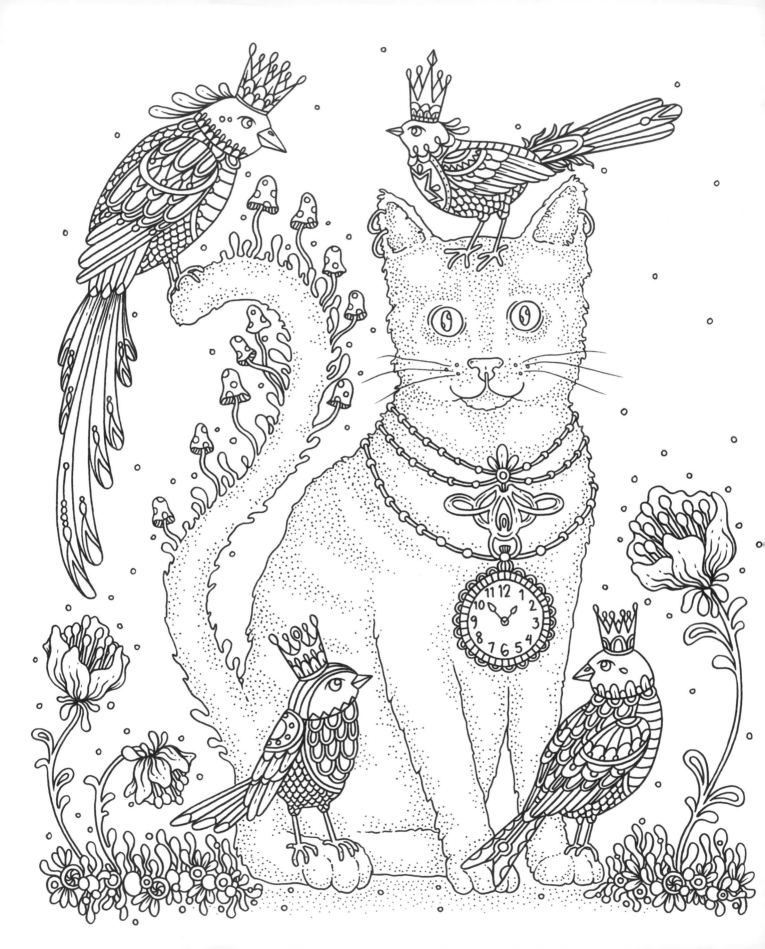

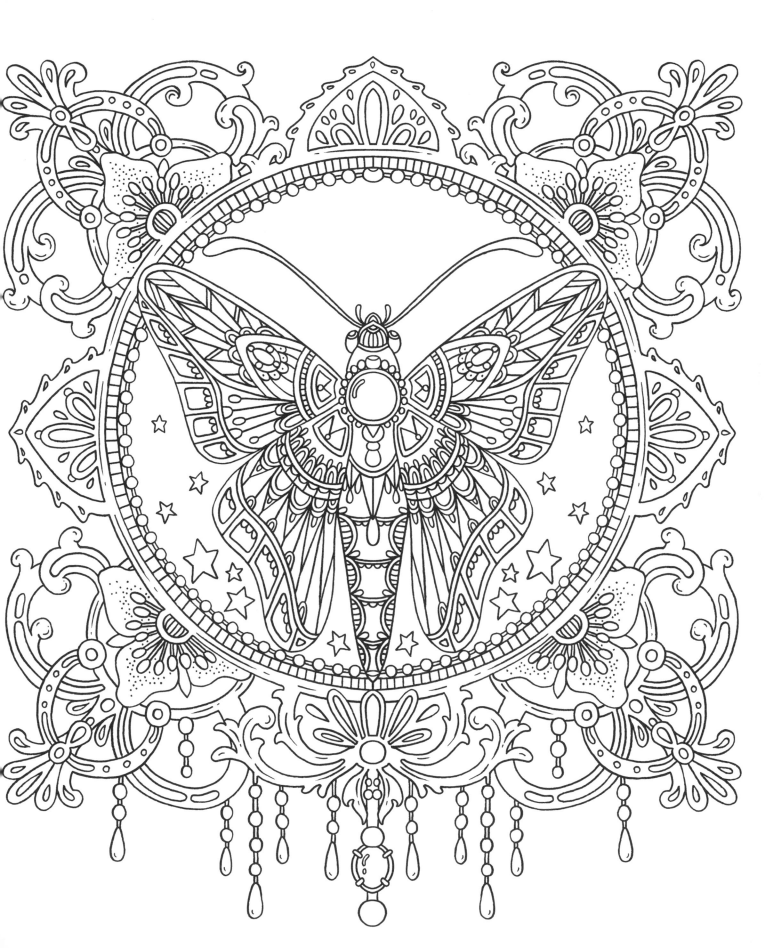

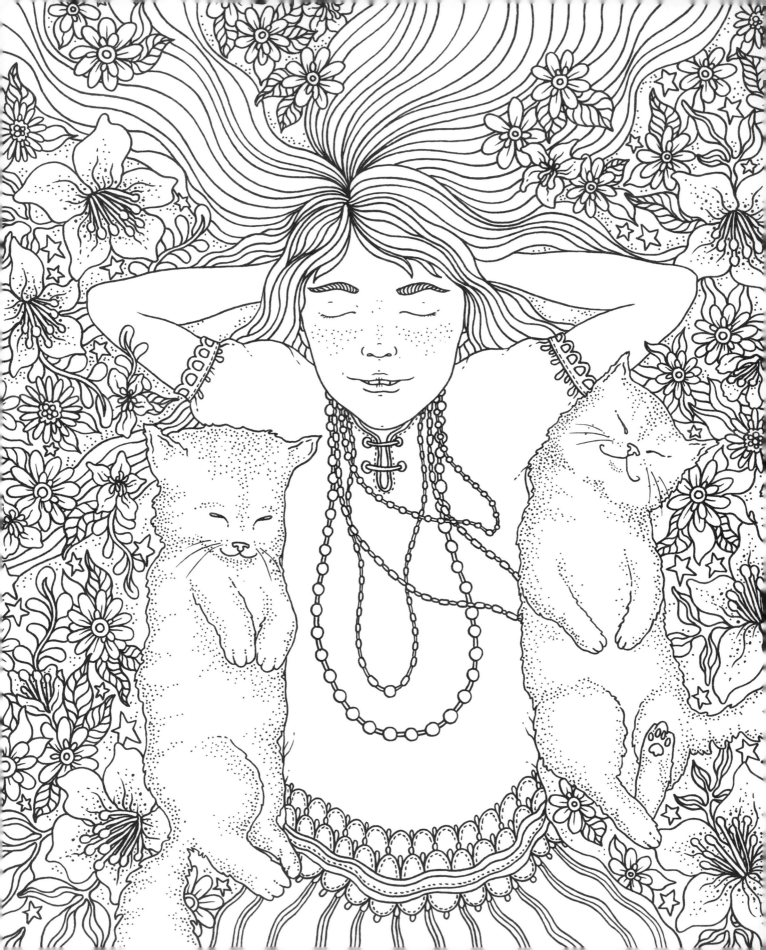

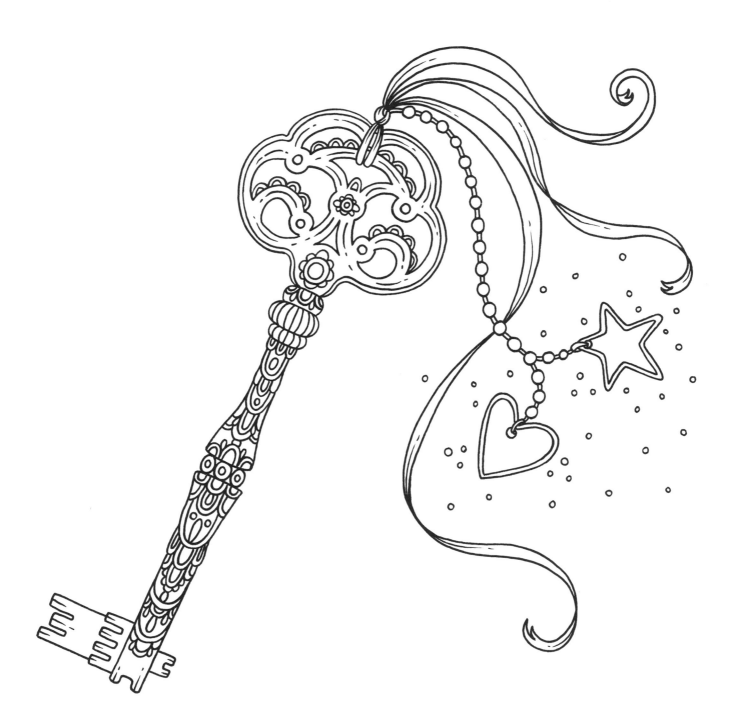

Dedicated to my family, friends,
and all the daydreamers
who color in my books.

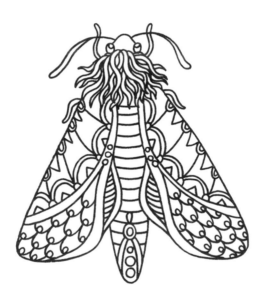